Geometric Designs and Patterns Coloring Book Volume 5

Over 50 designs to help relax and stay inspired

Gholamreza Zare & Pegah Malekpour Alamdari

This book belongs to:

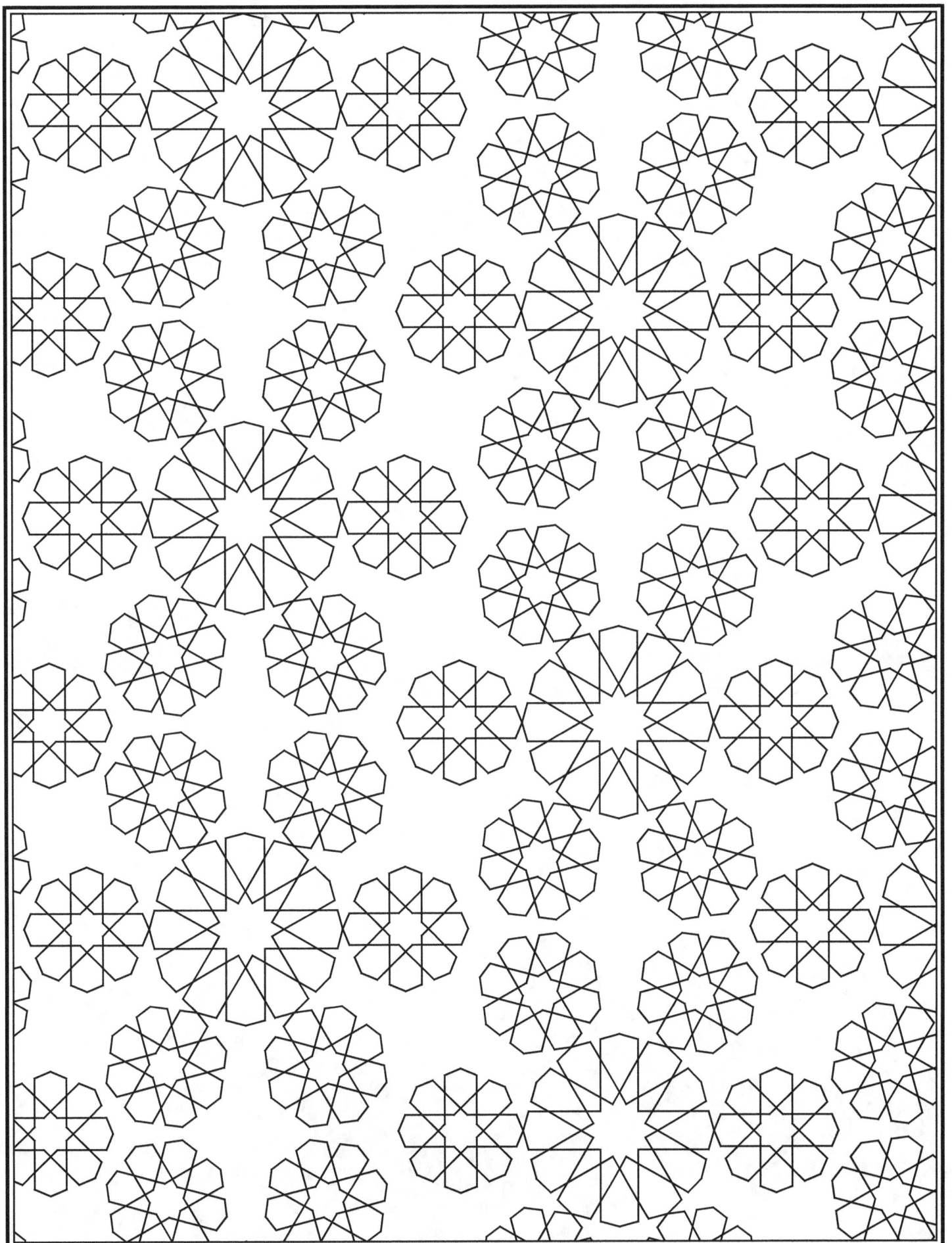

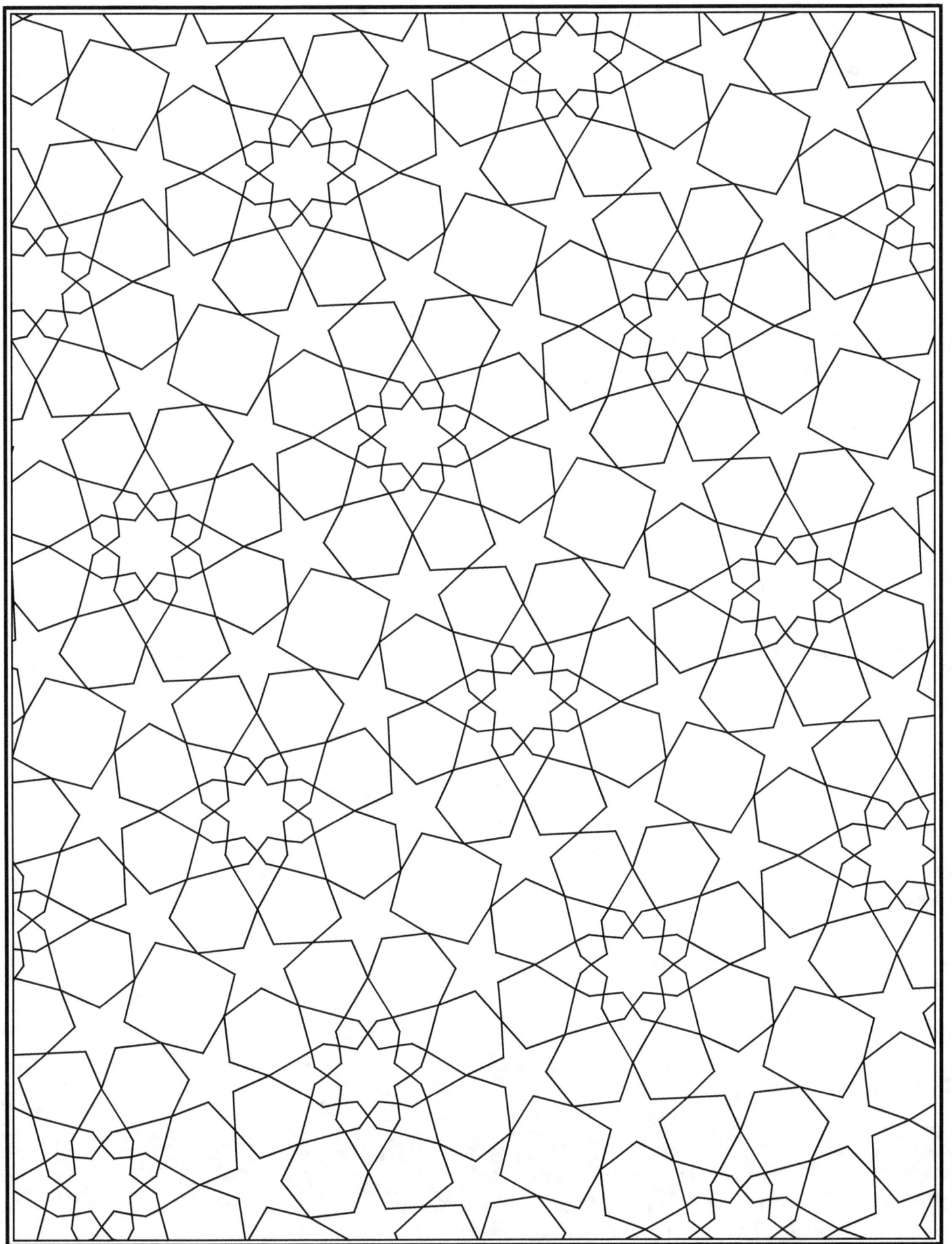

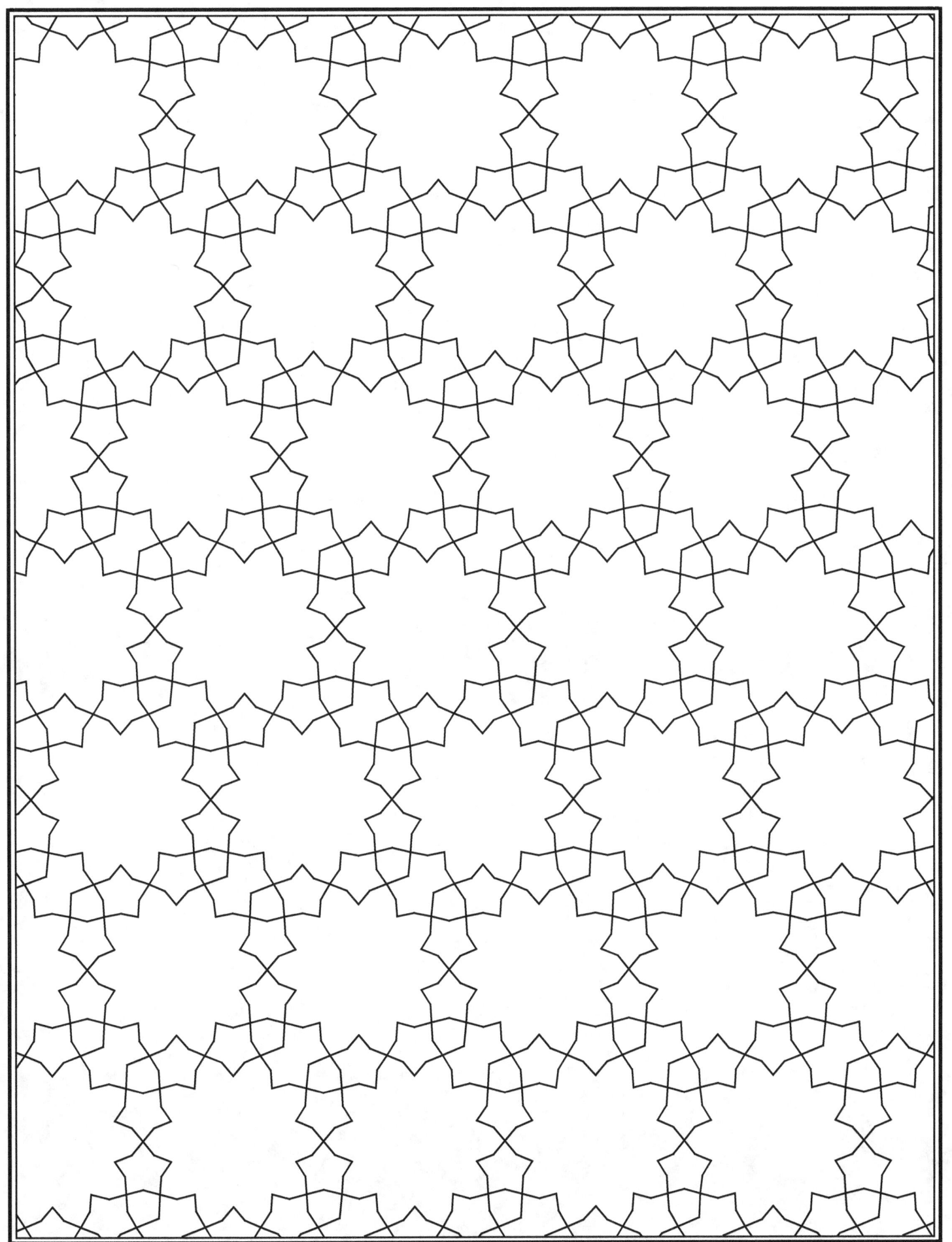

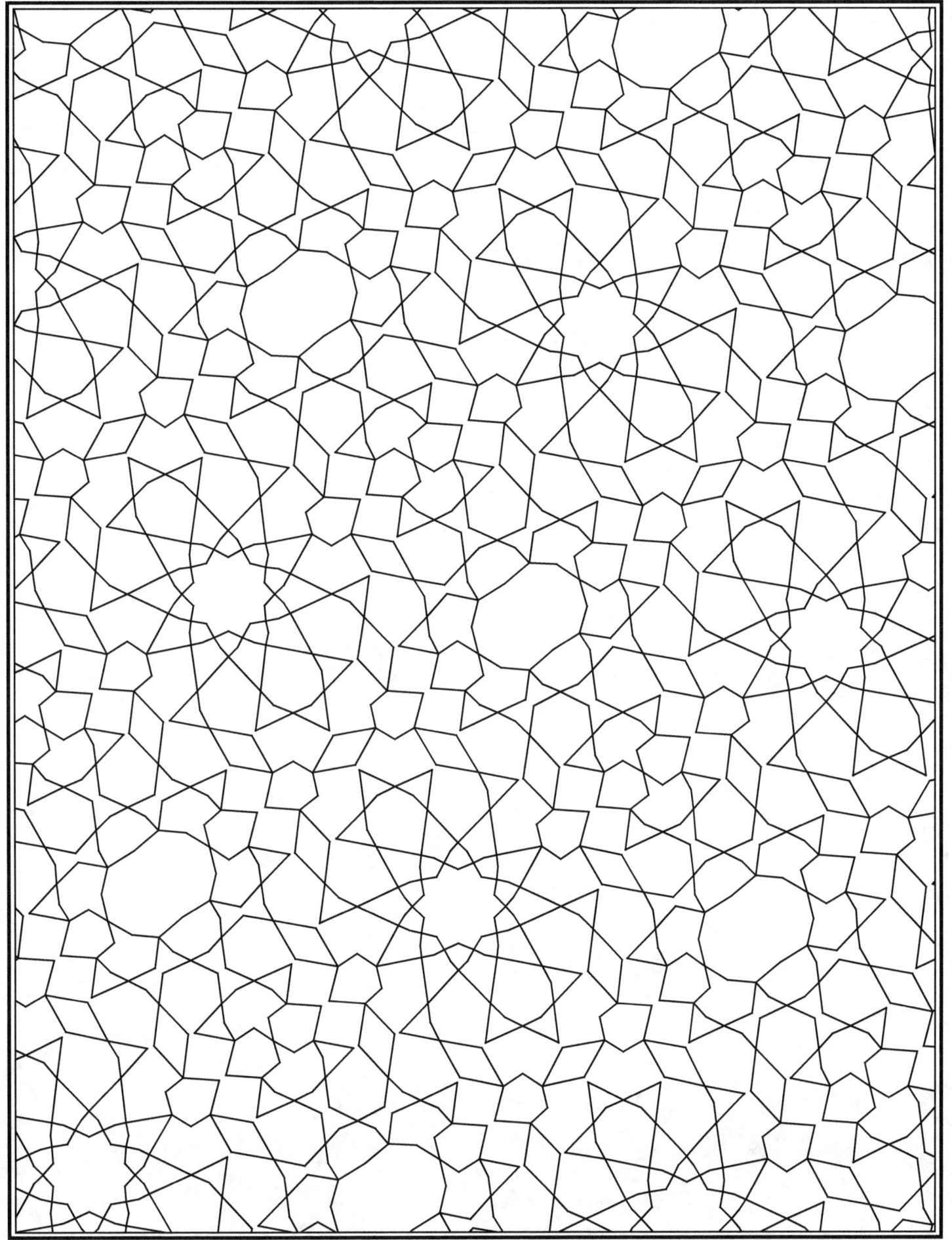

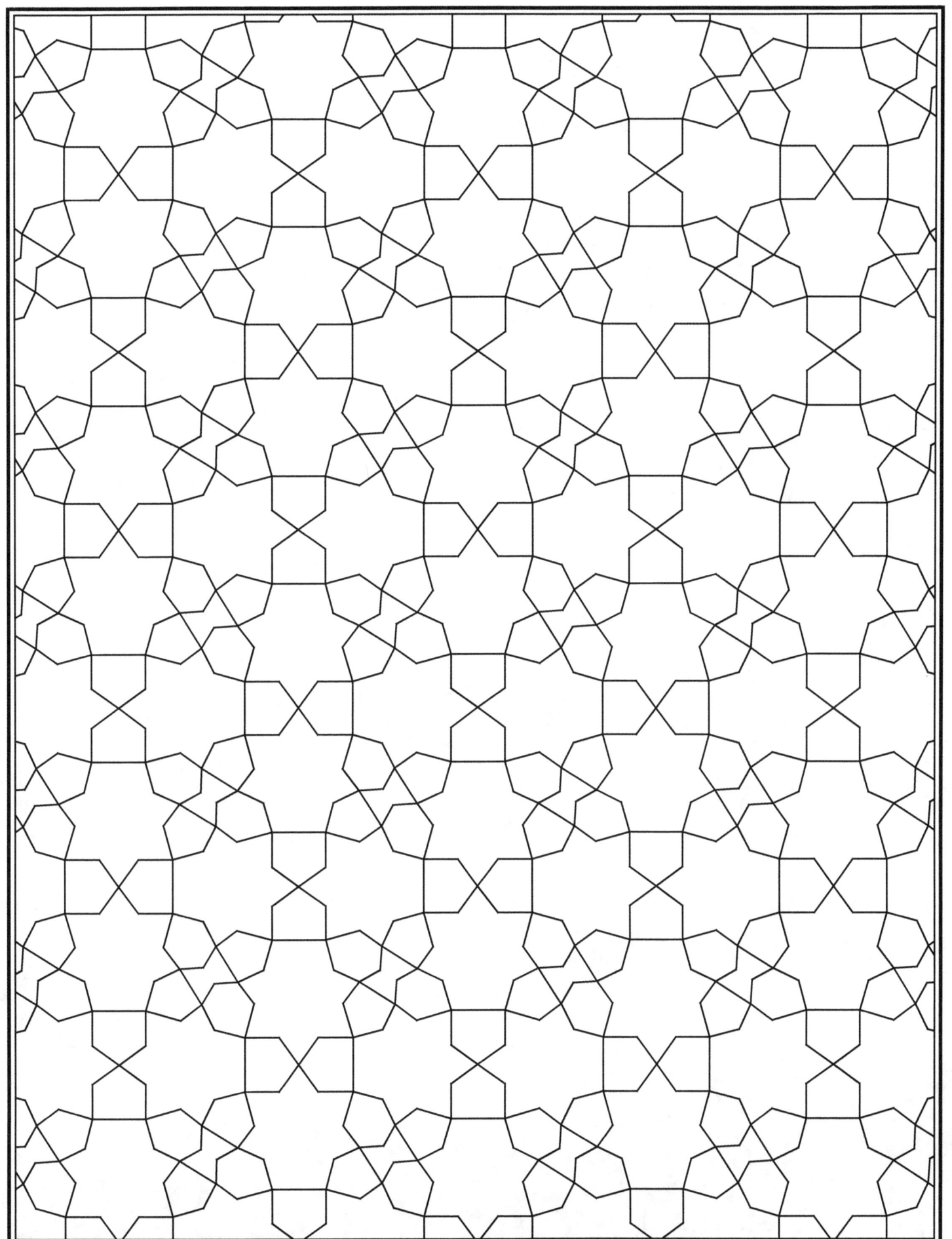

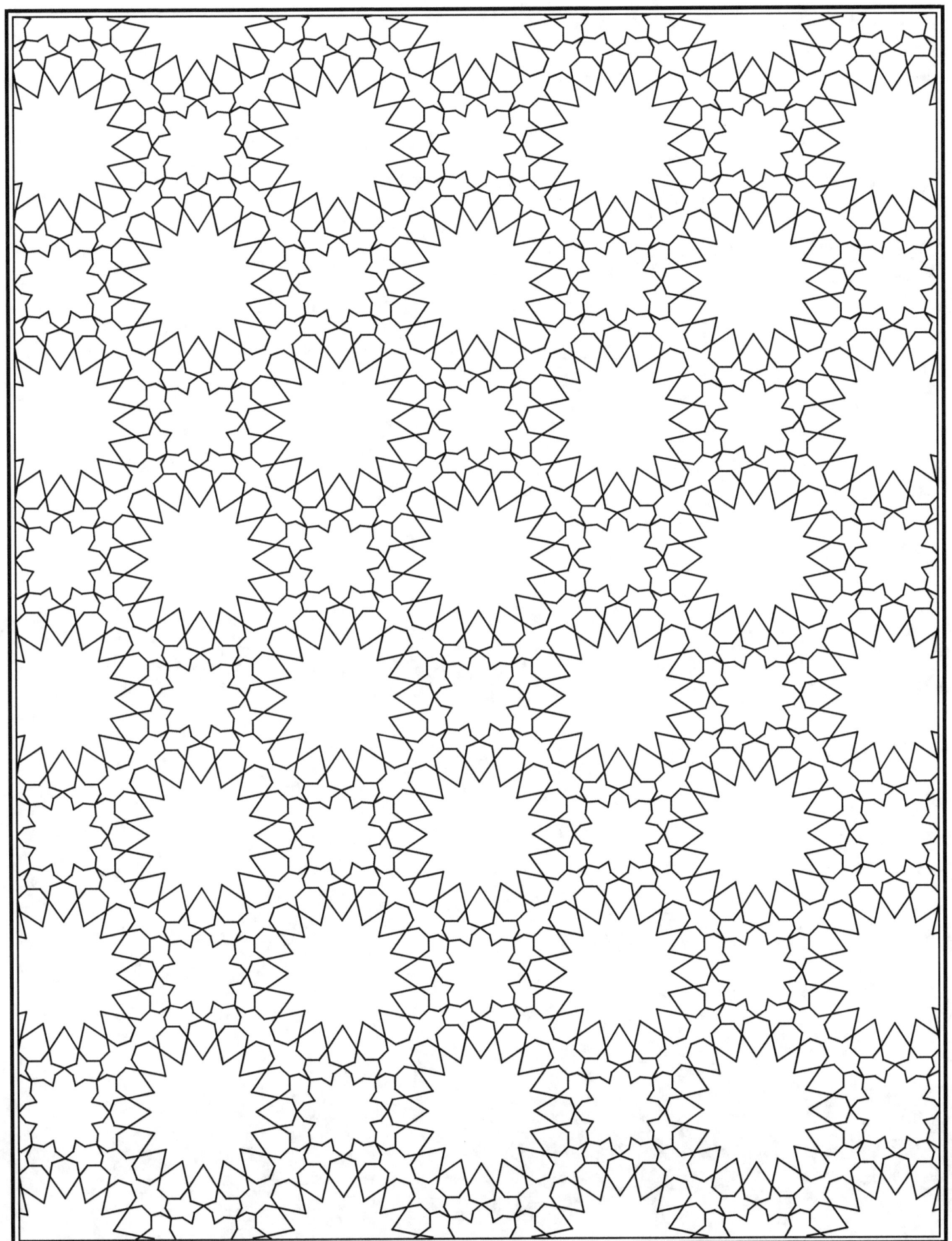

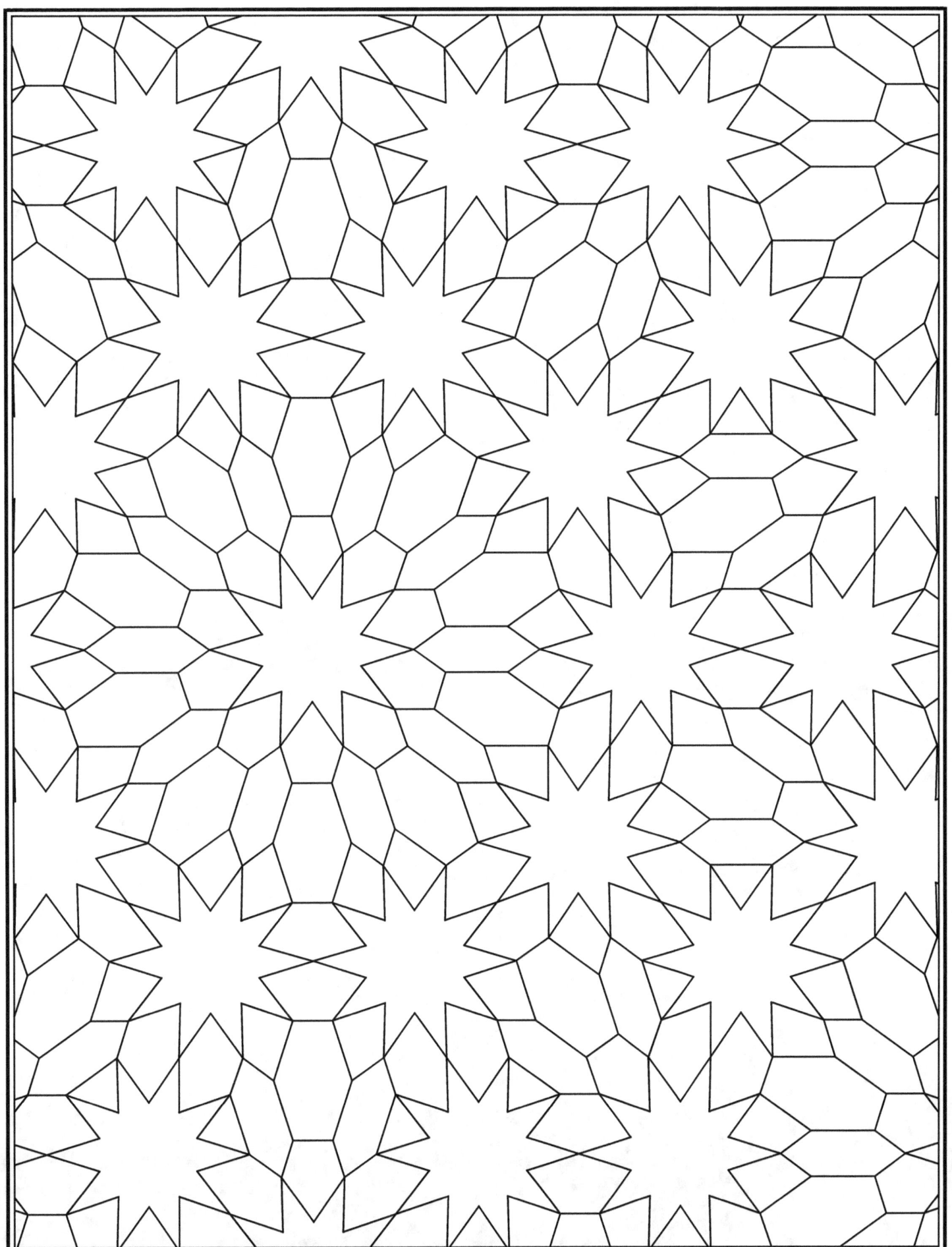

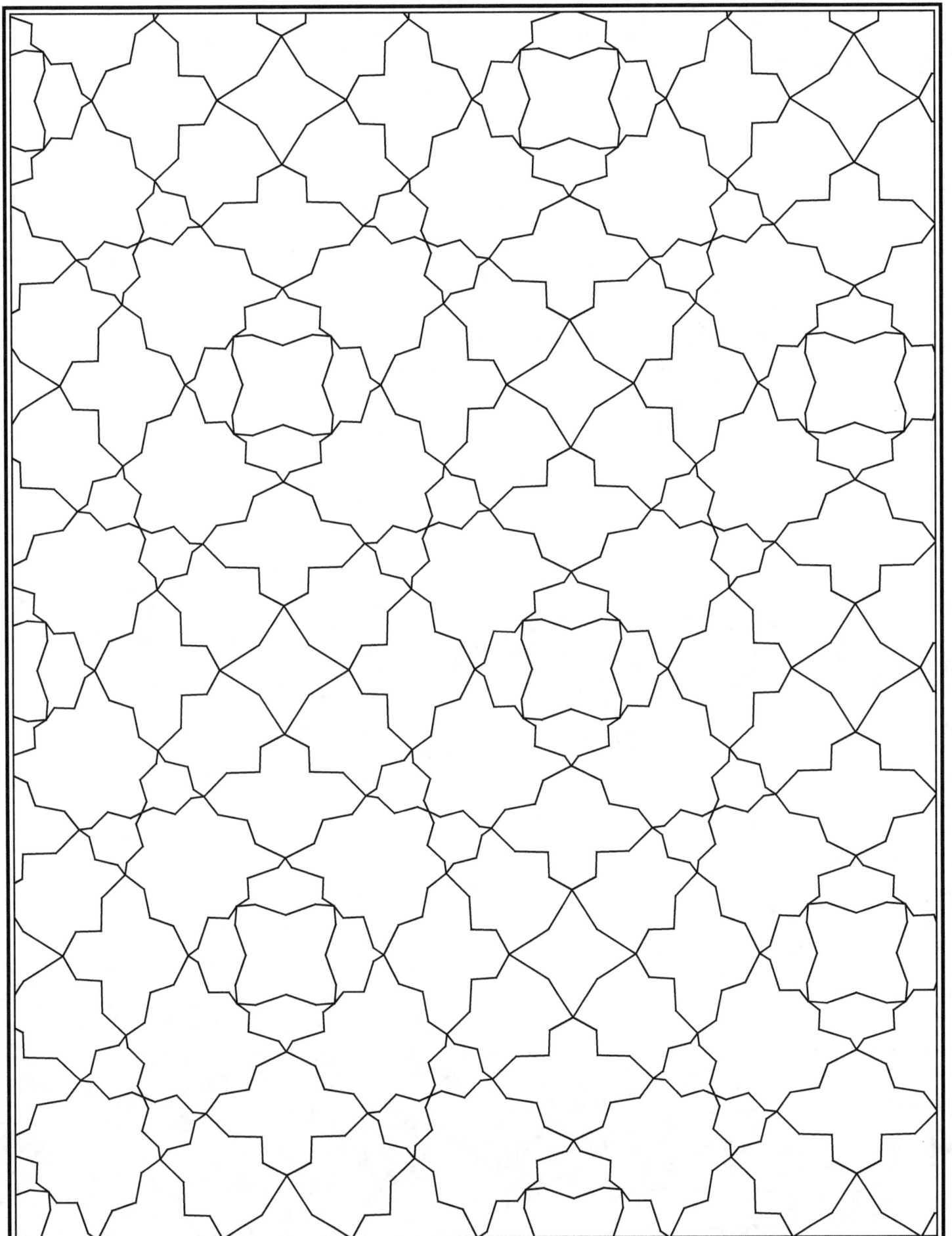

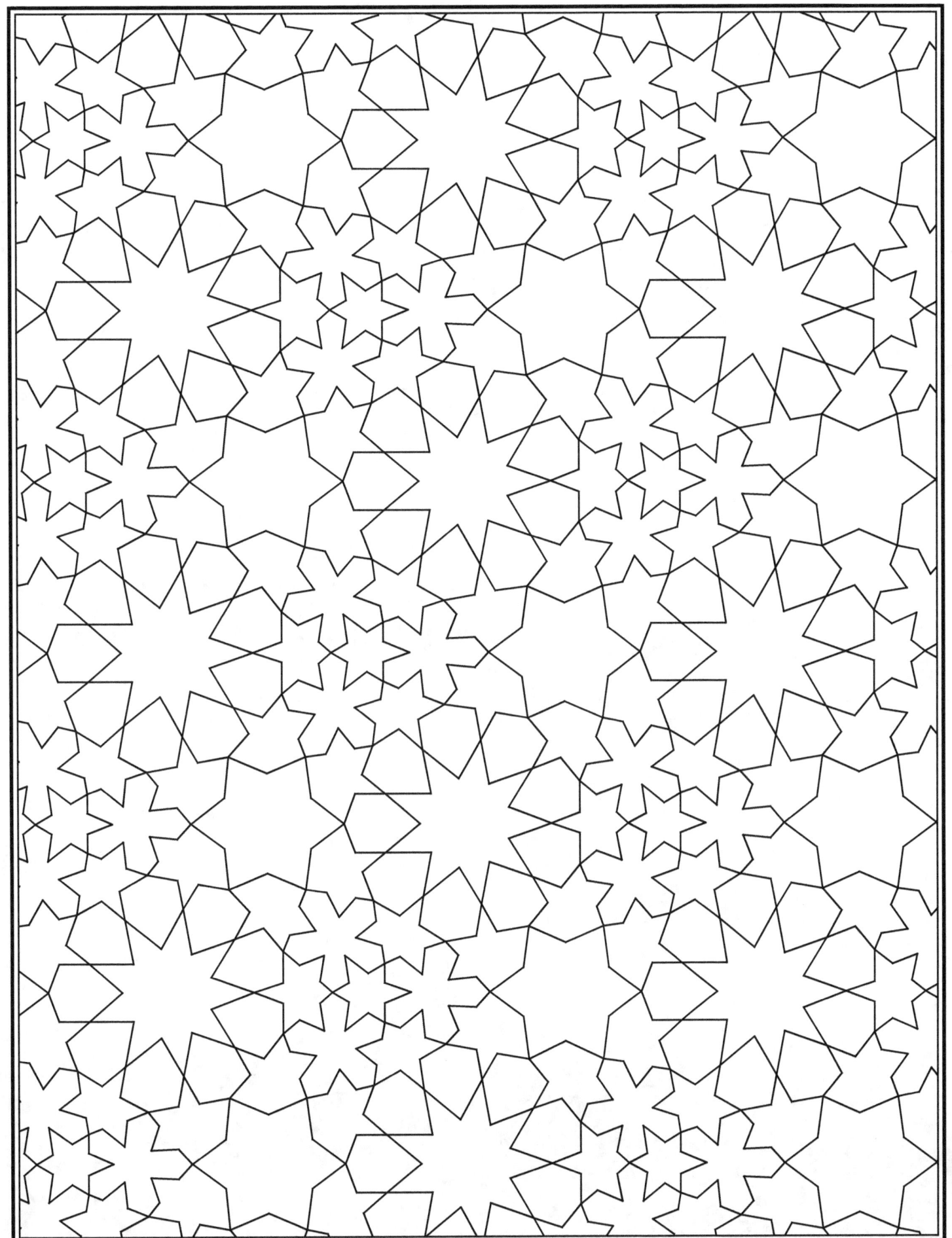

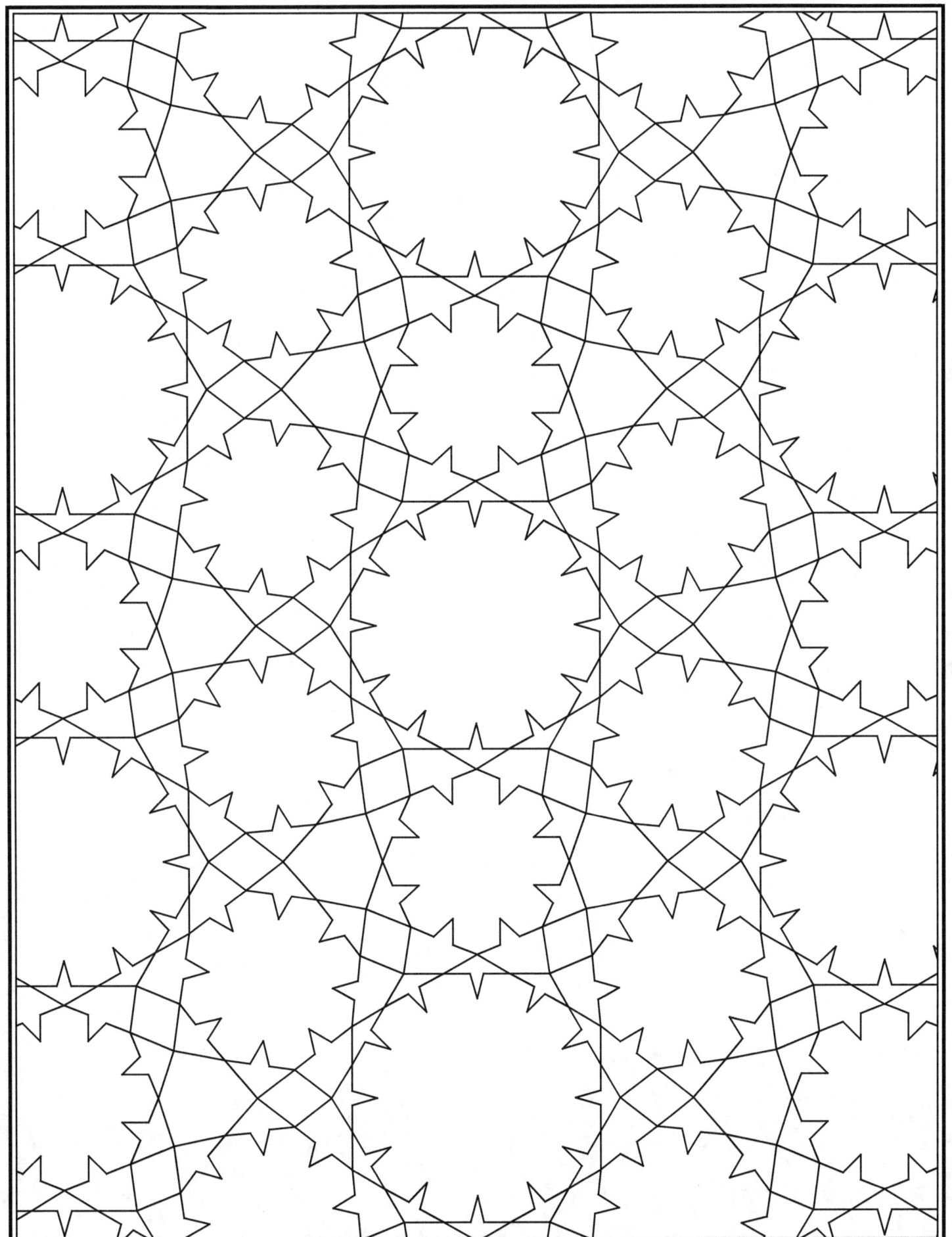

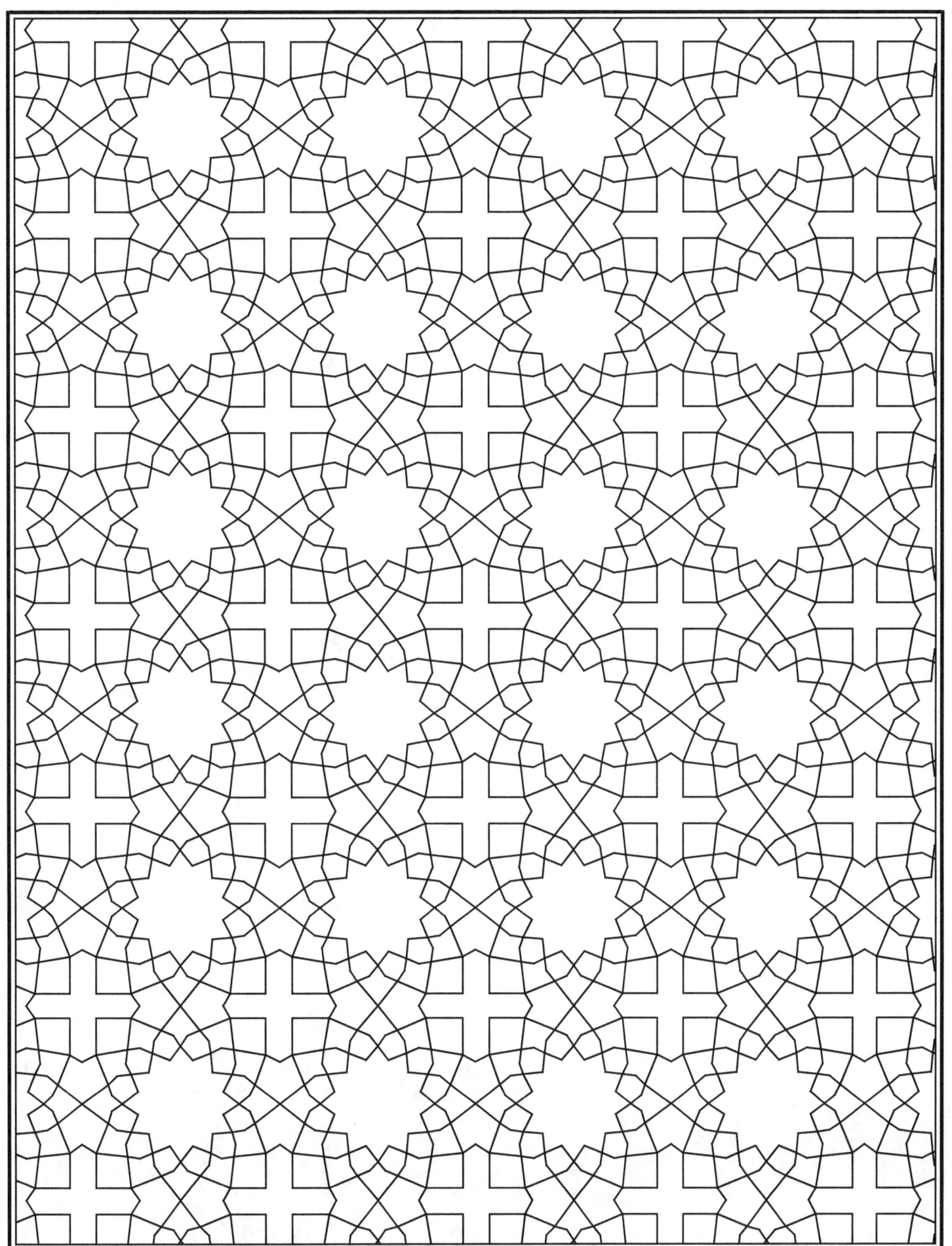

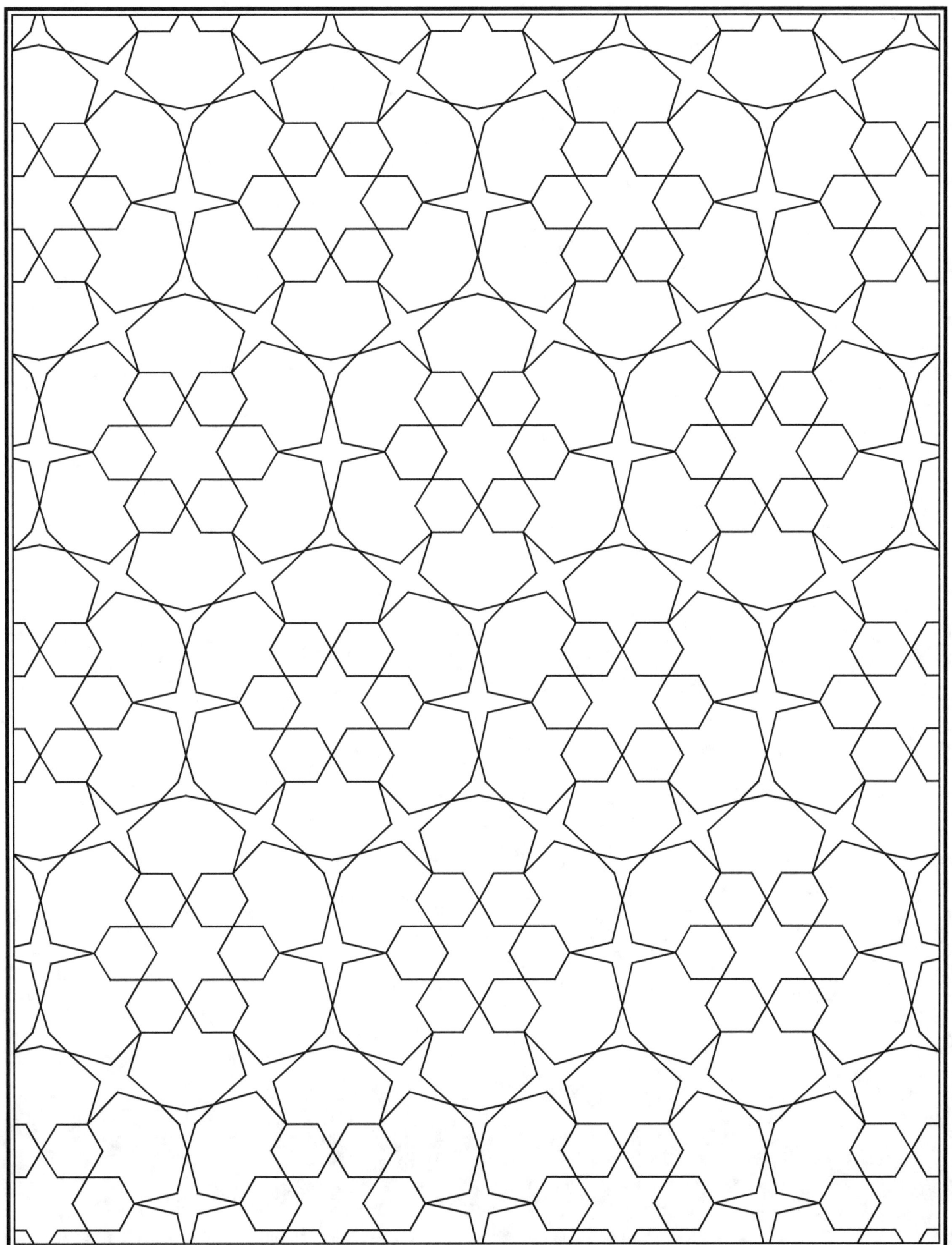

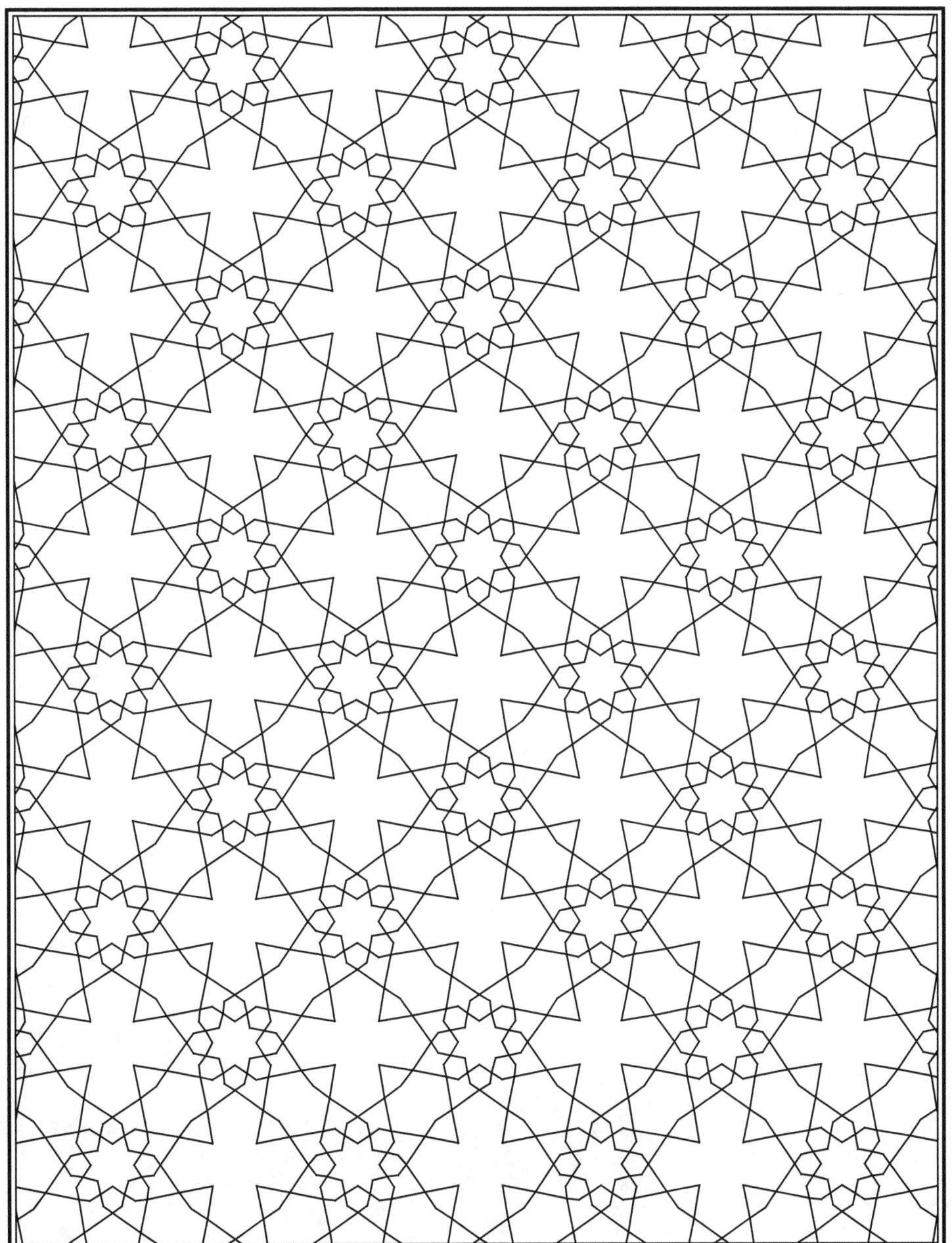

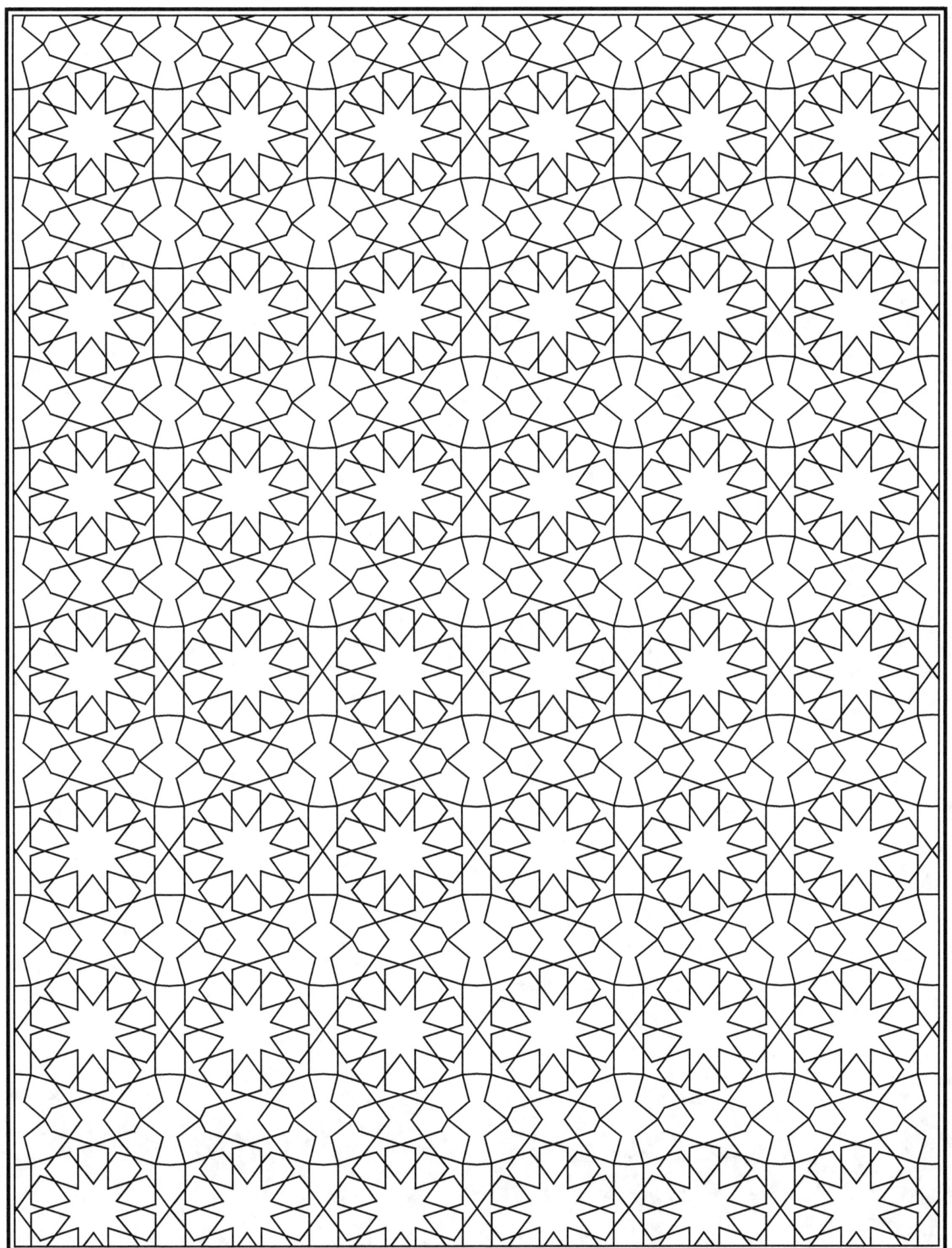

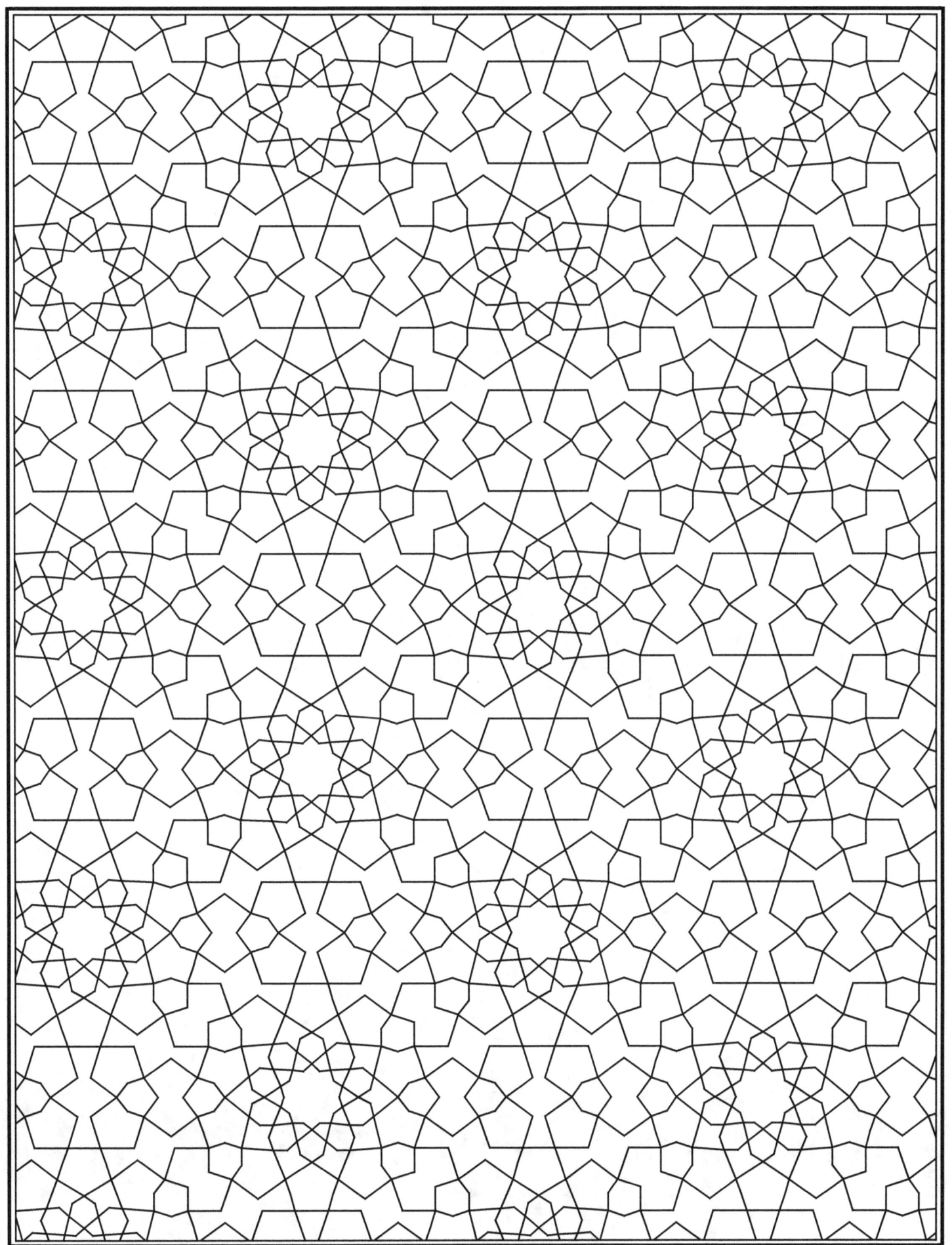

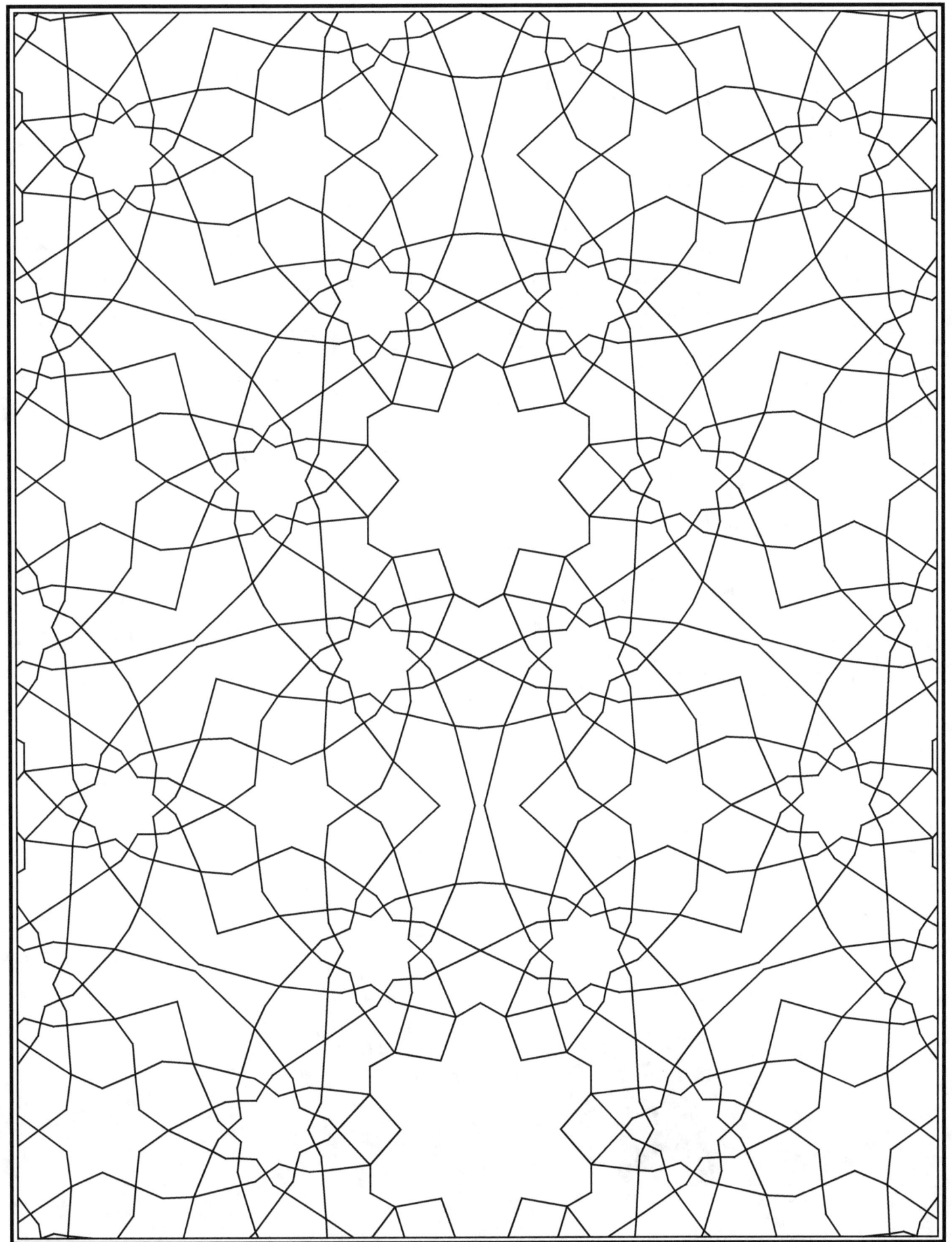

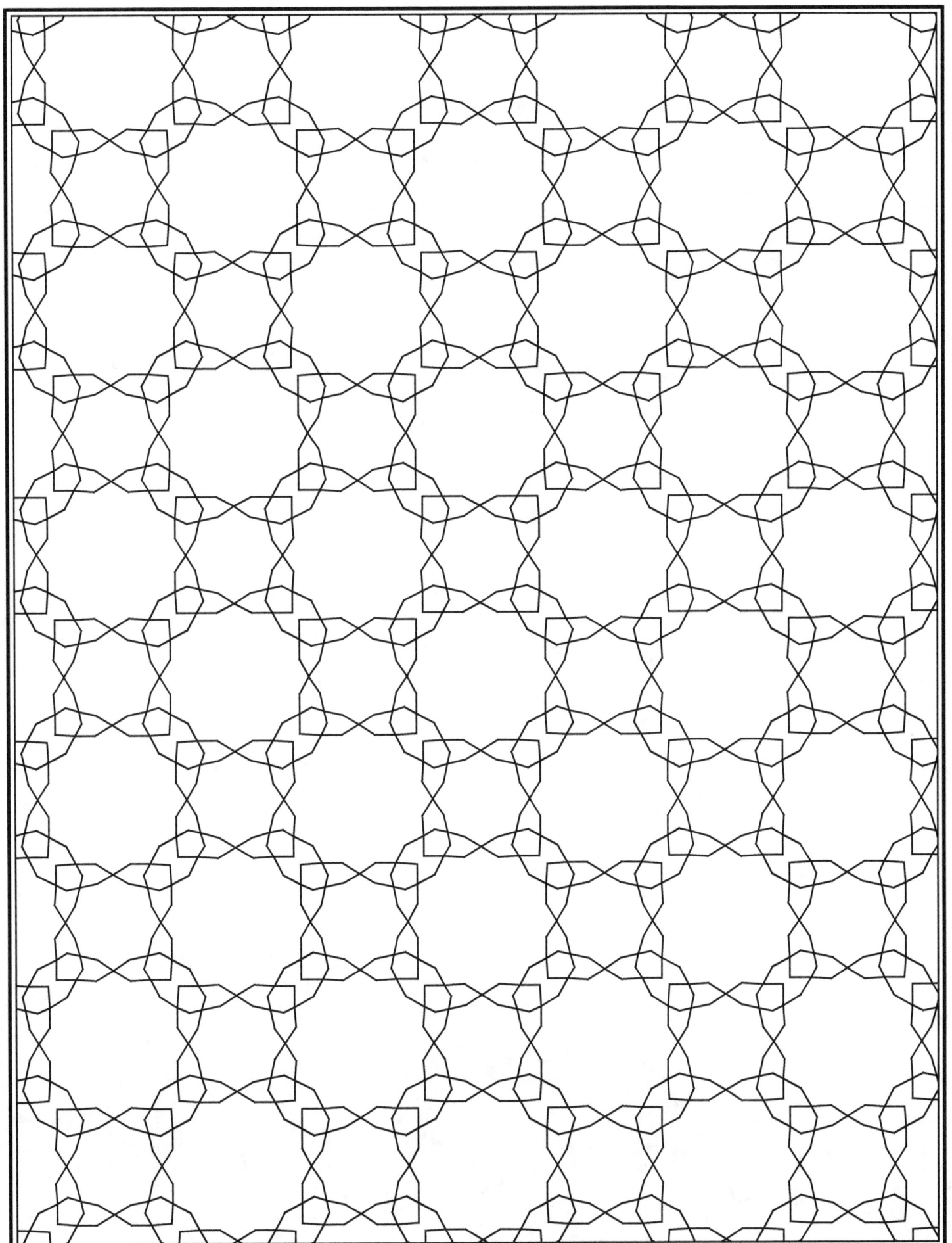

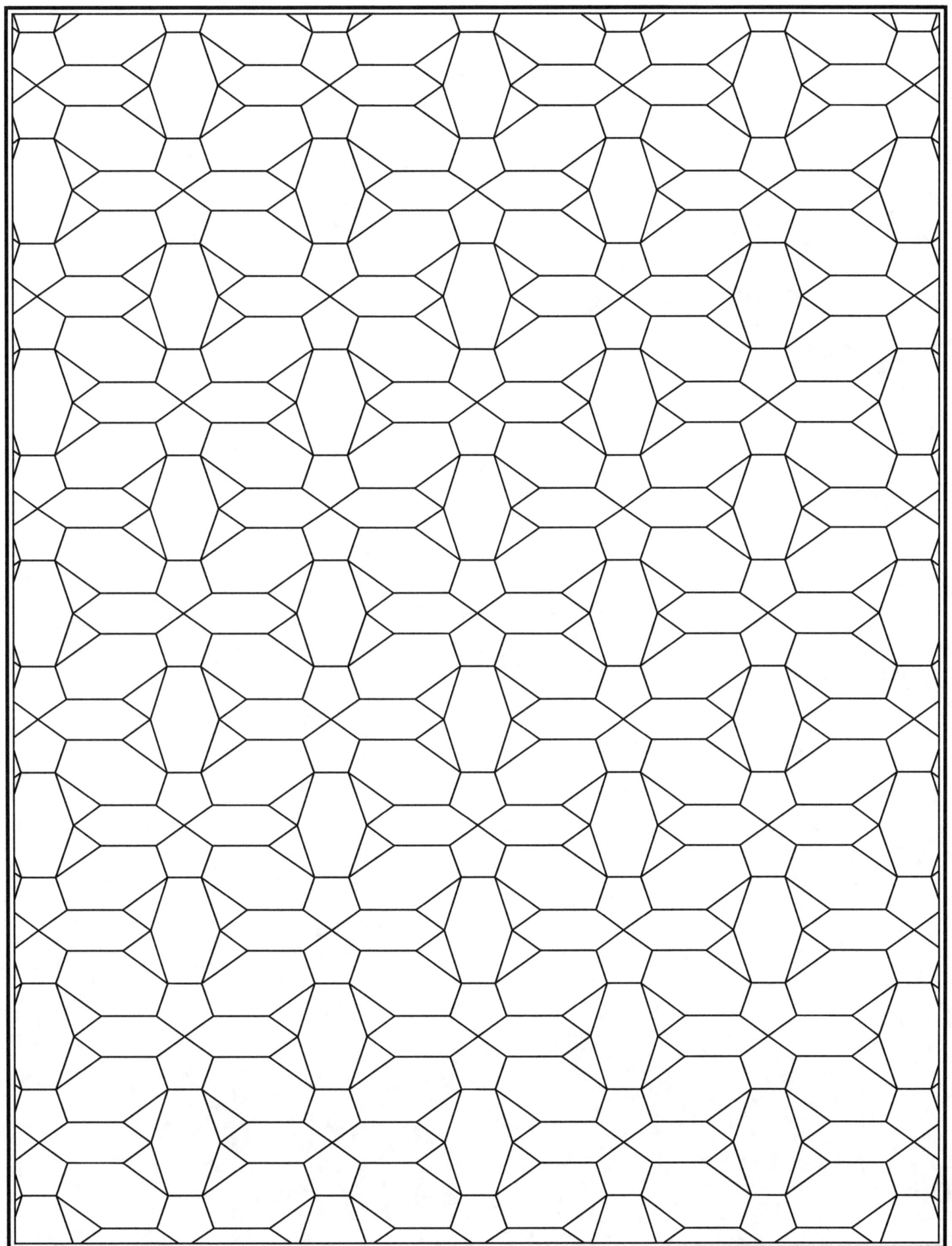

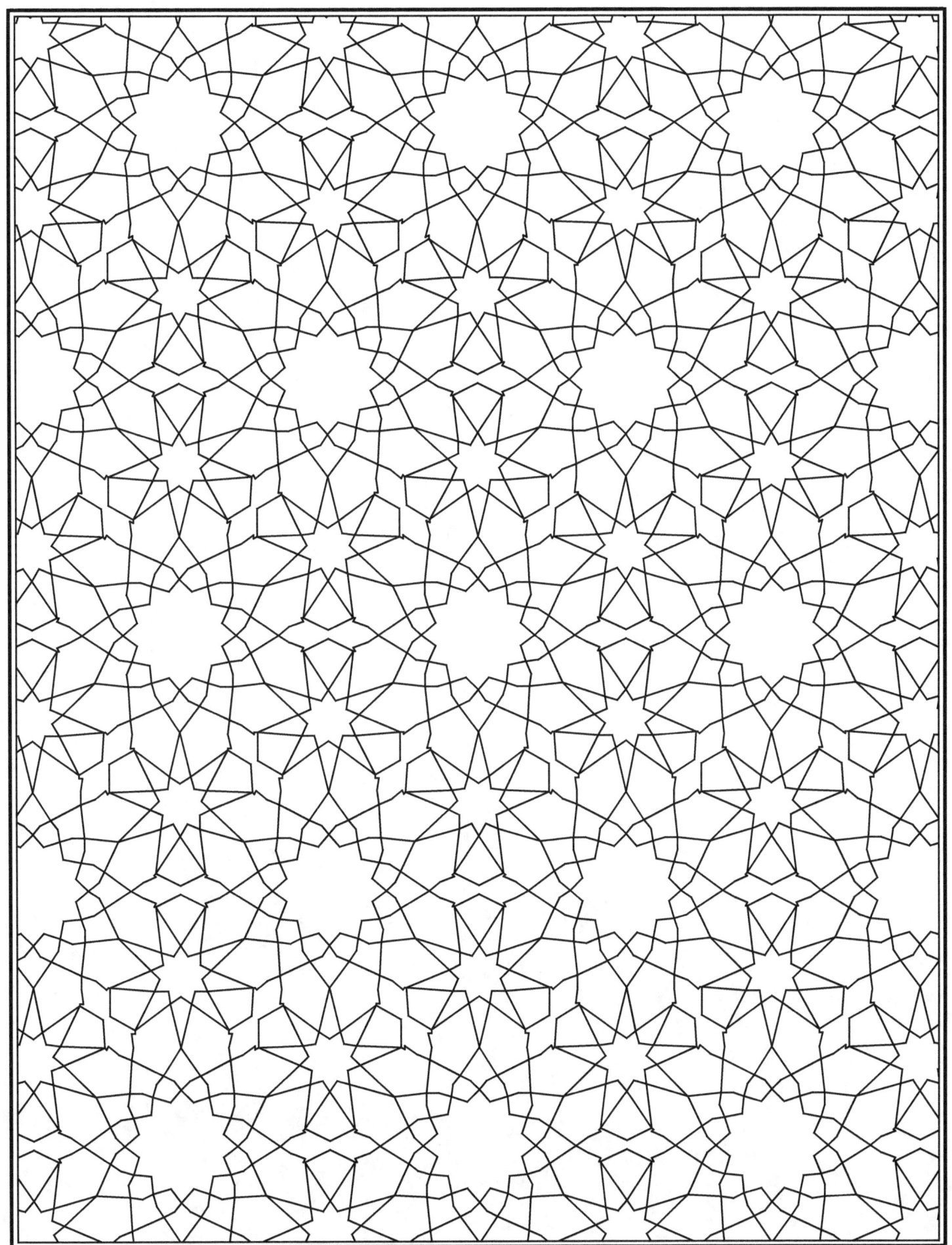

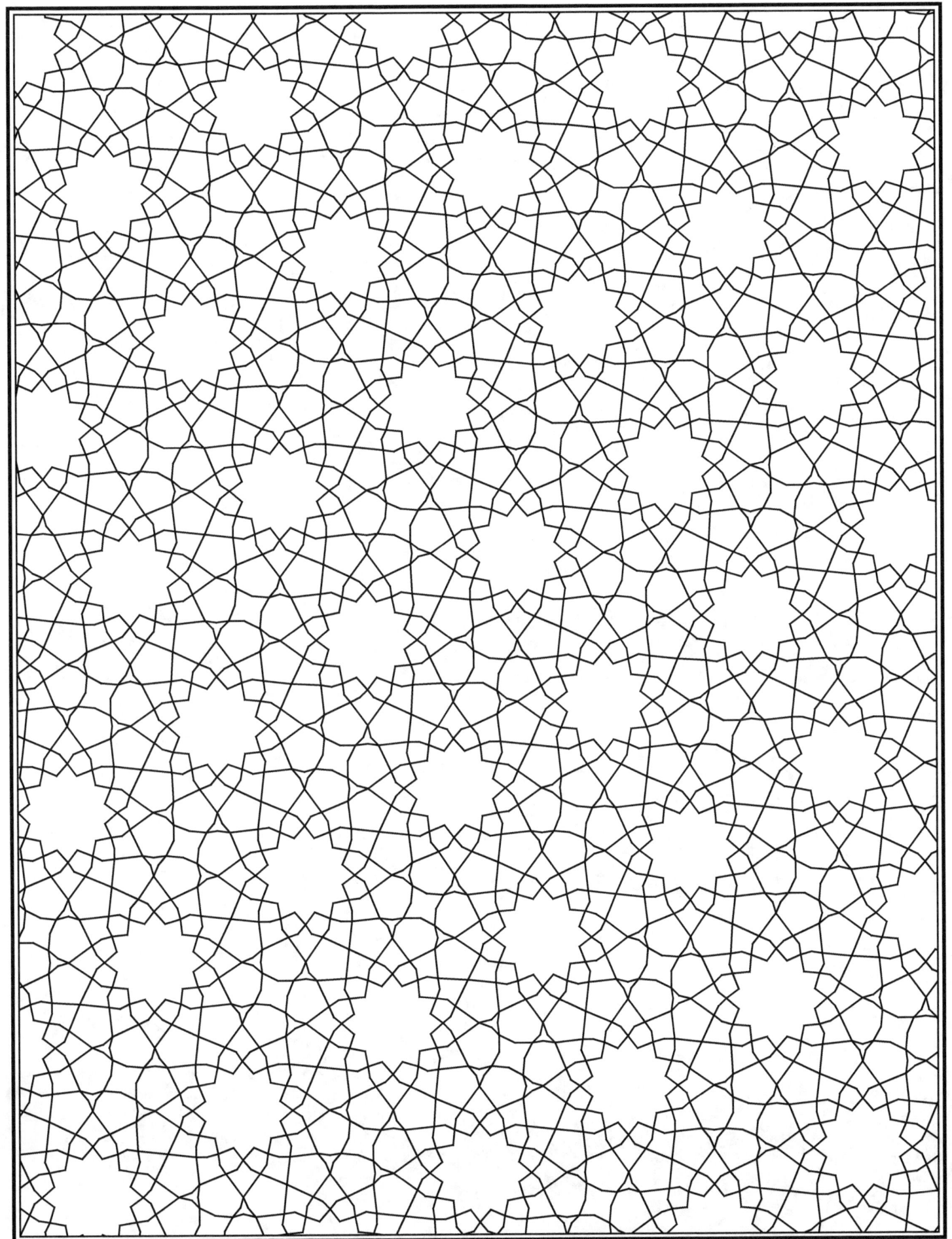

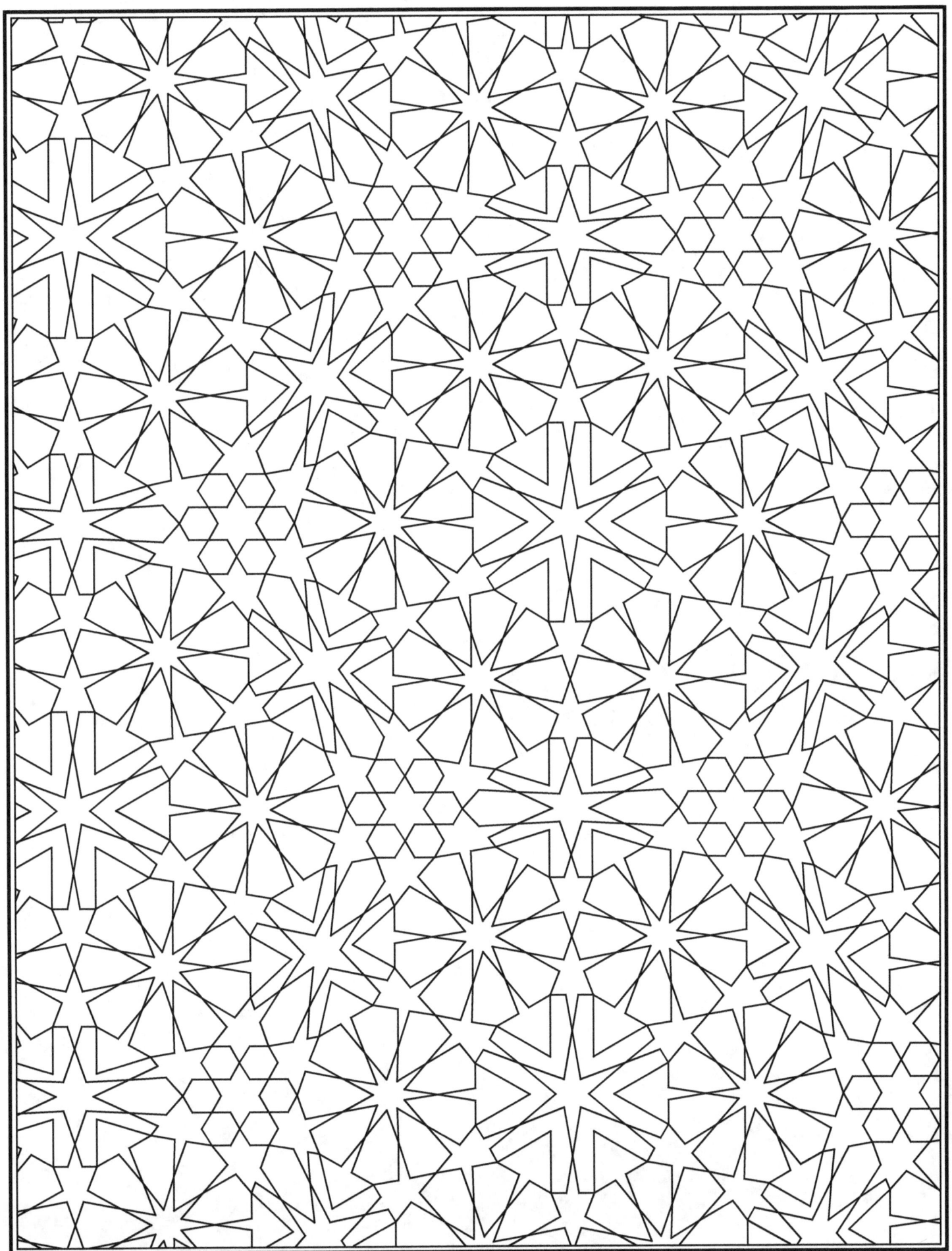

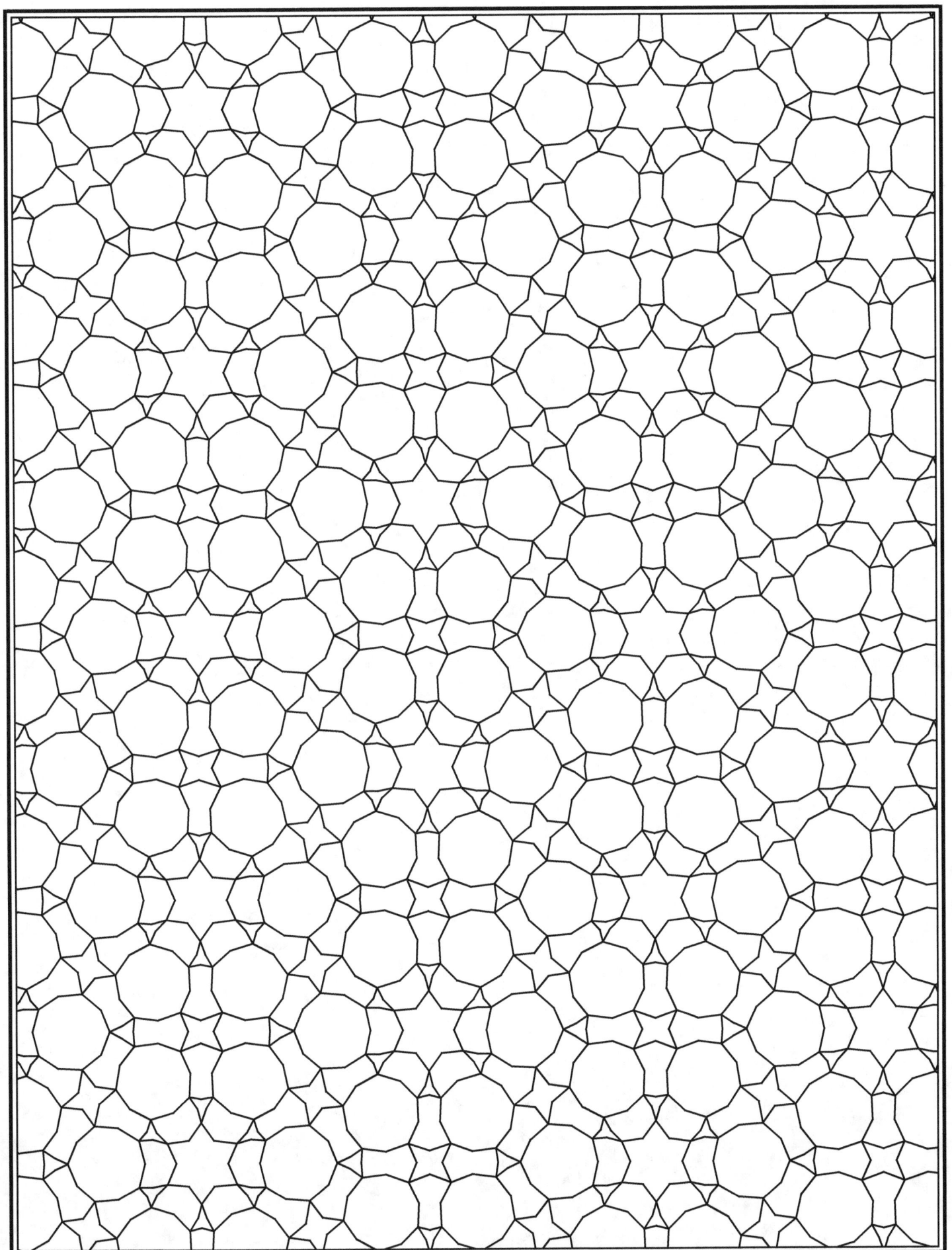

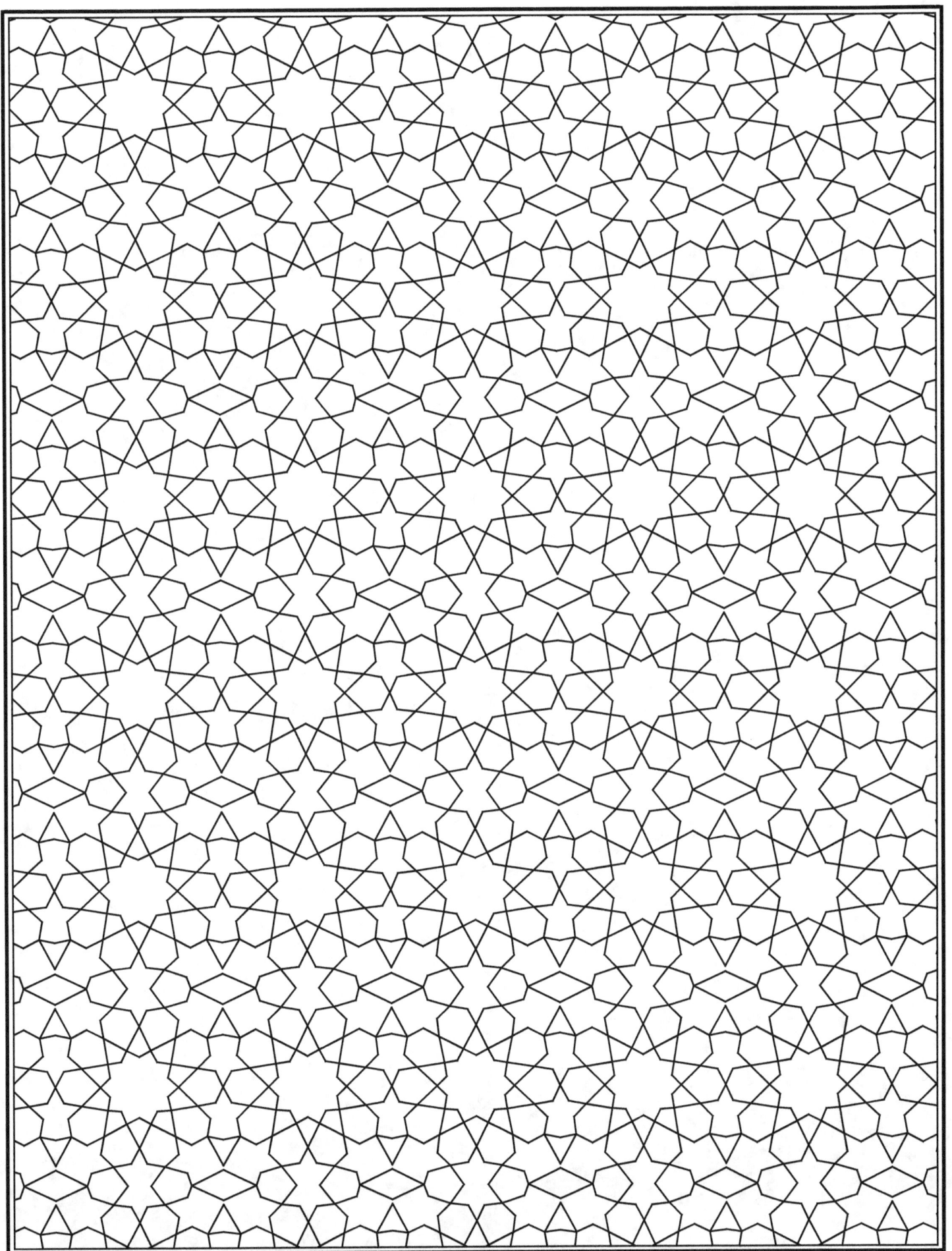

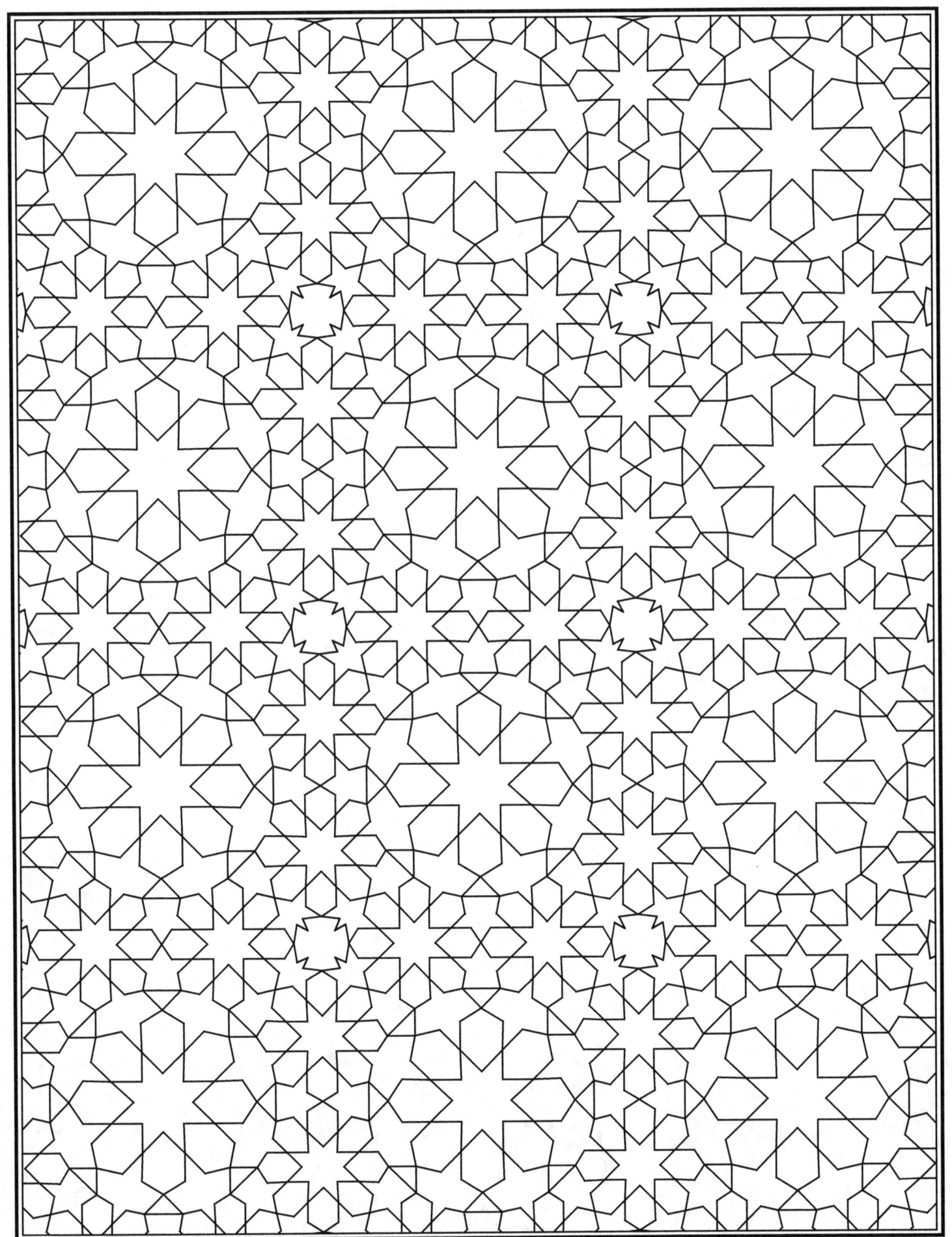

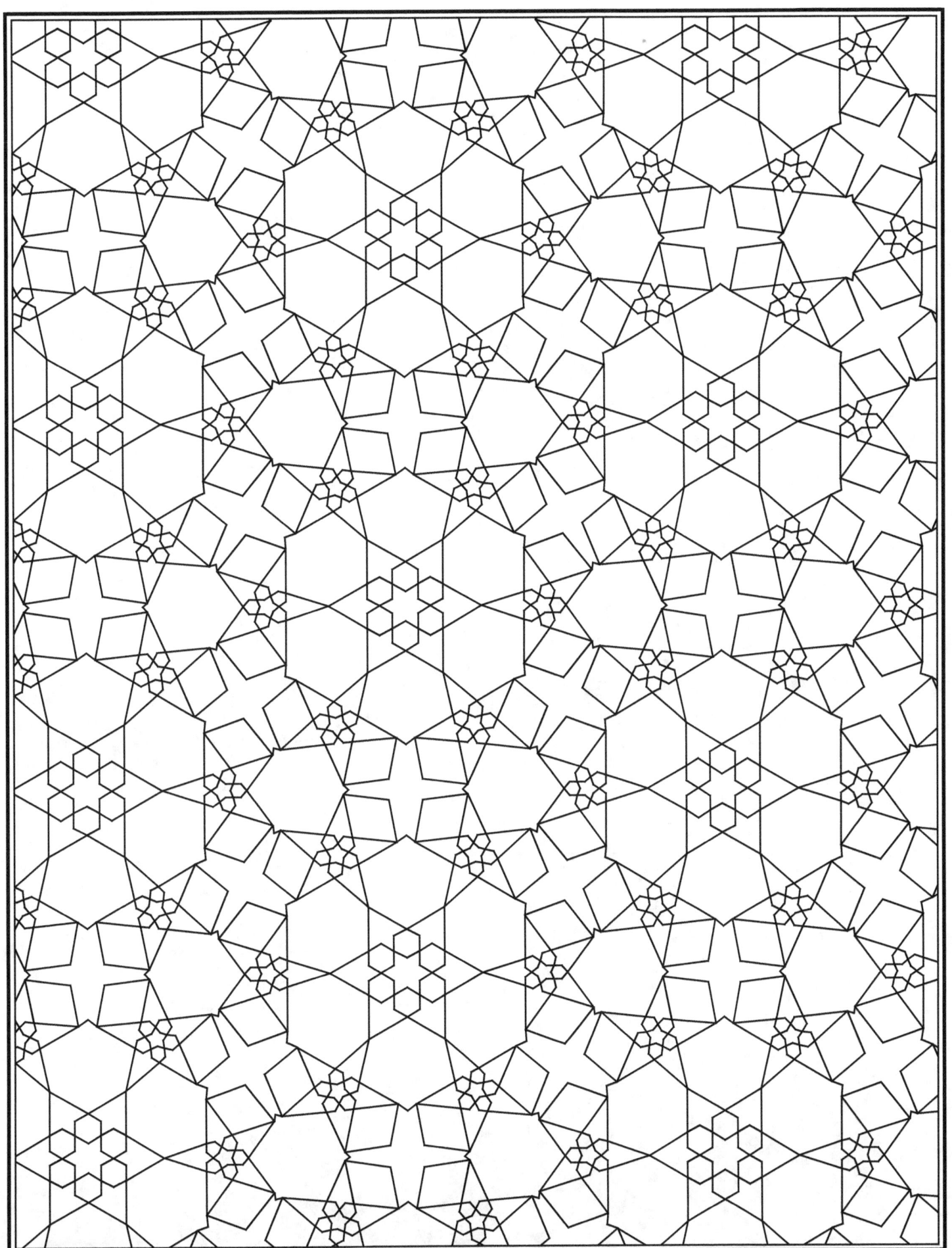

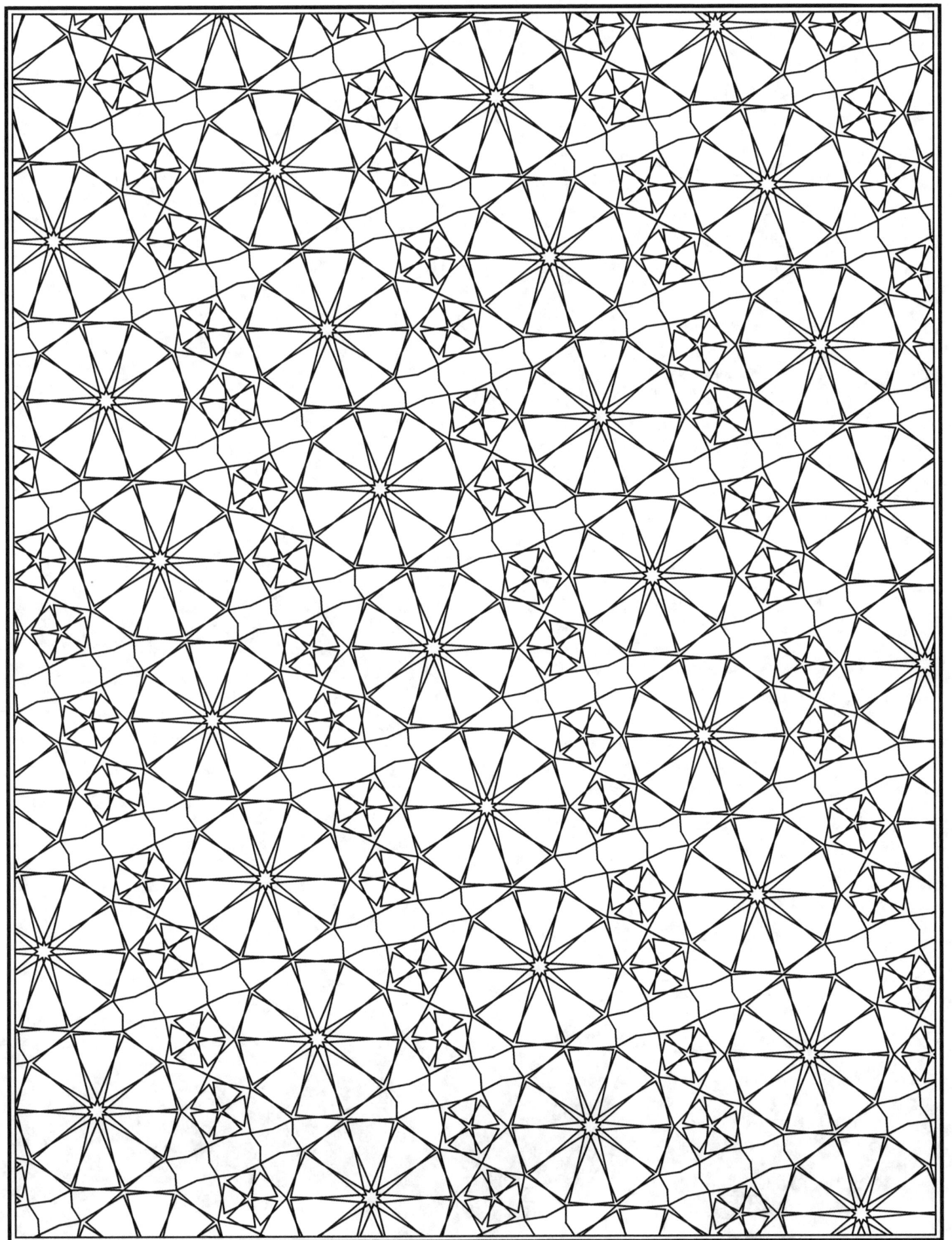

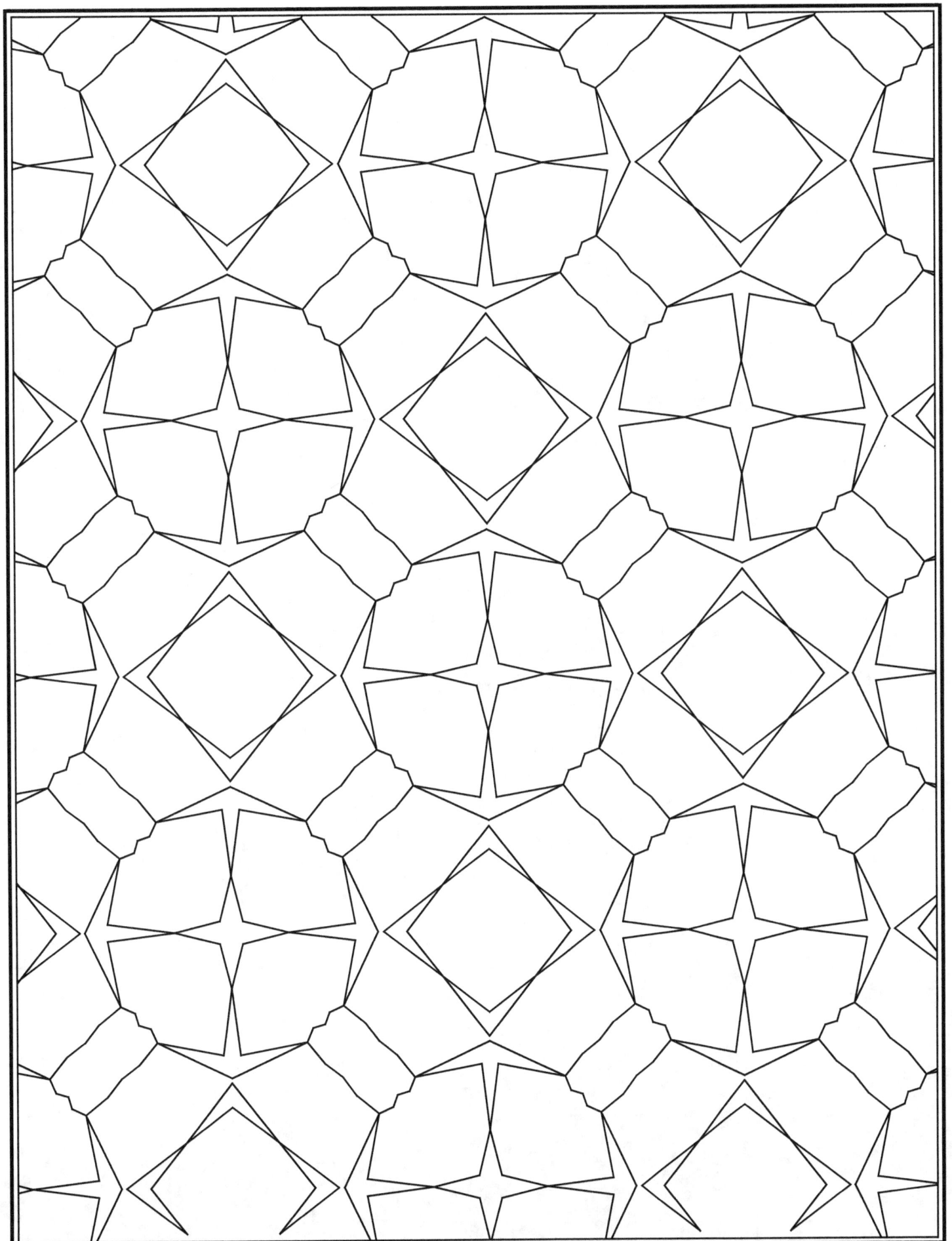

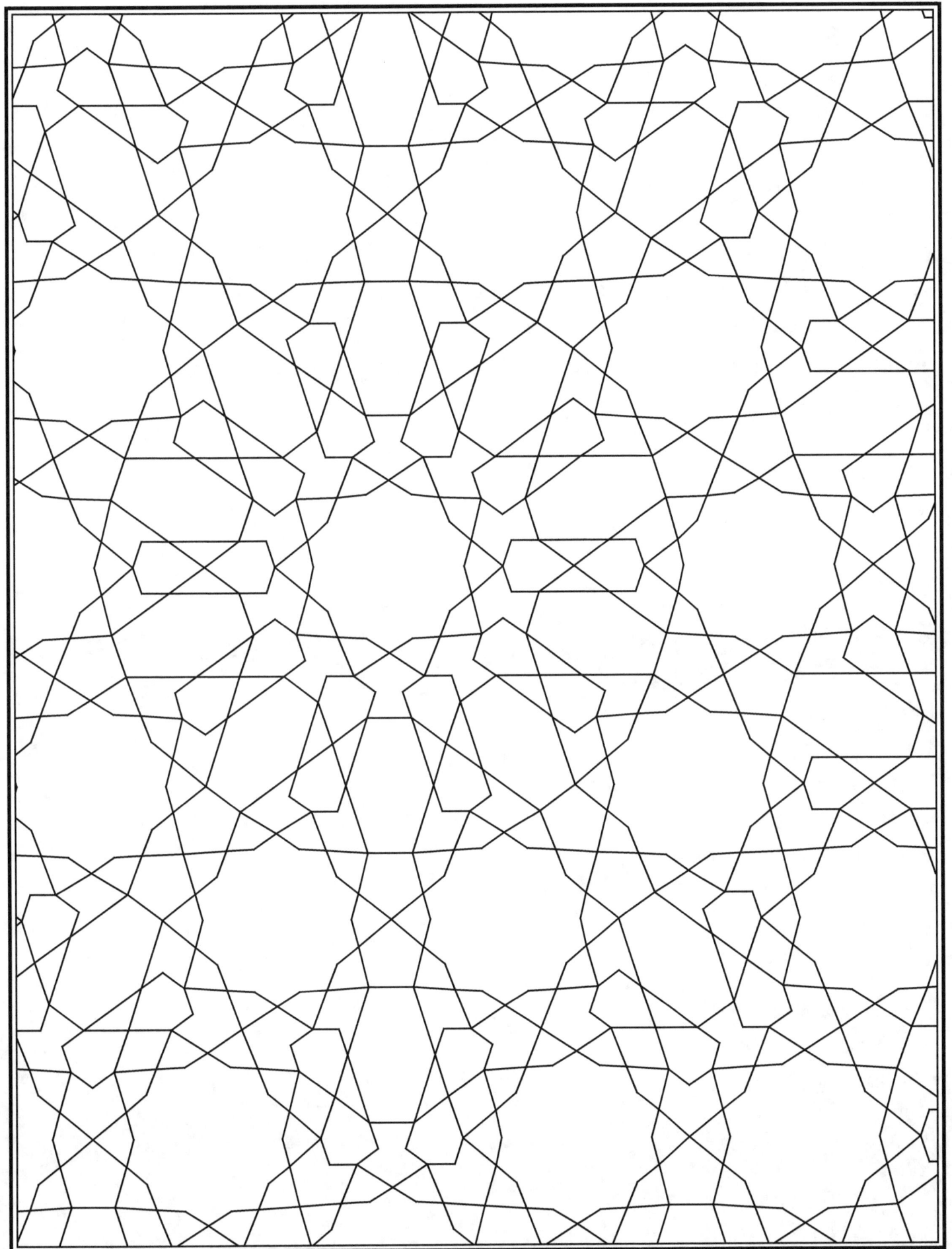

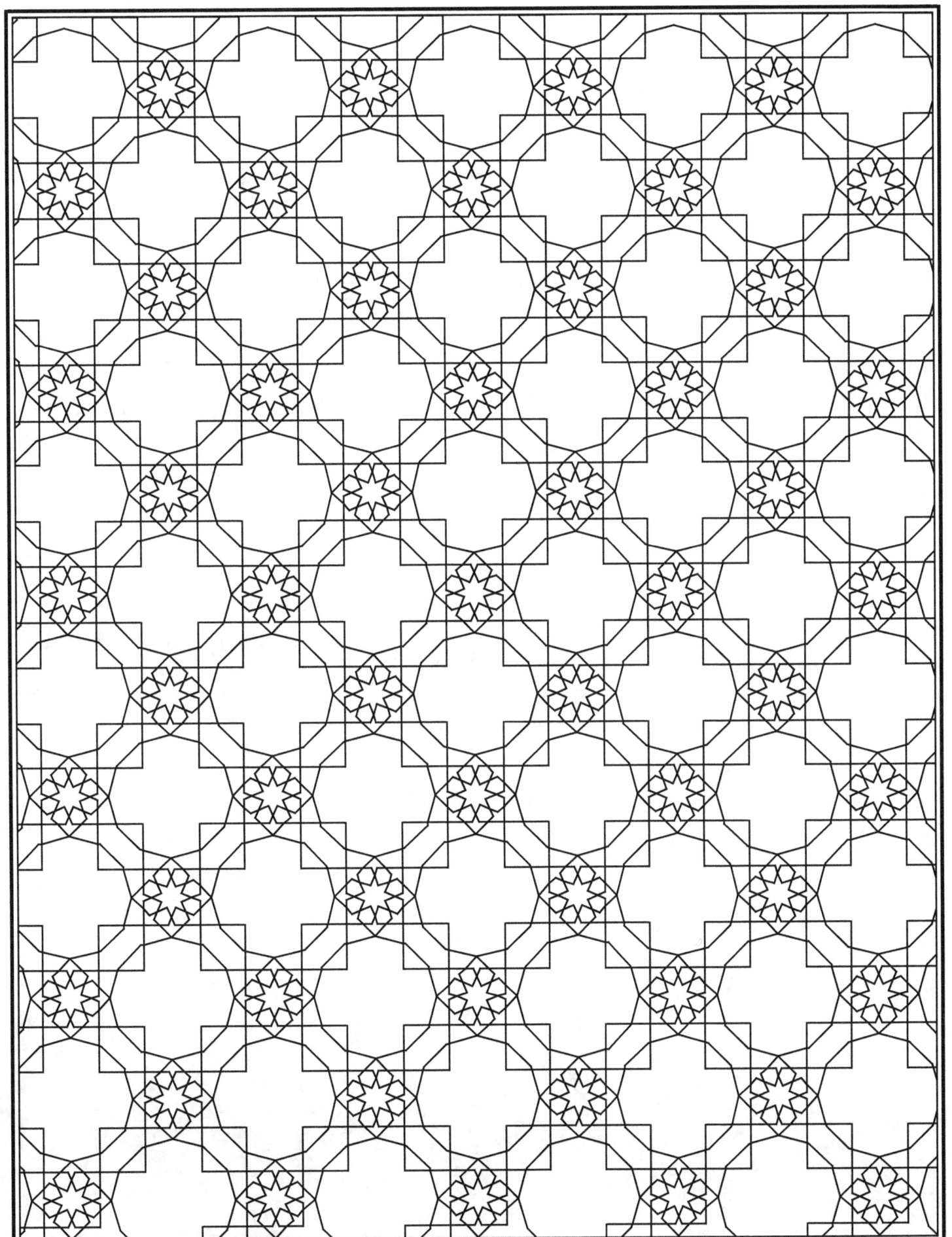

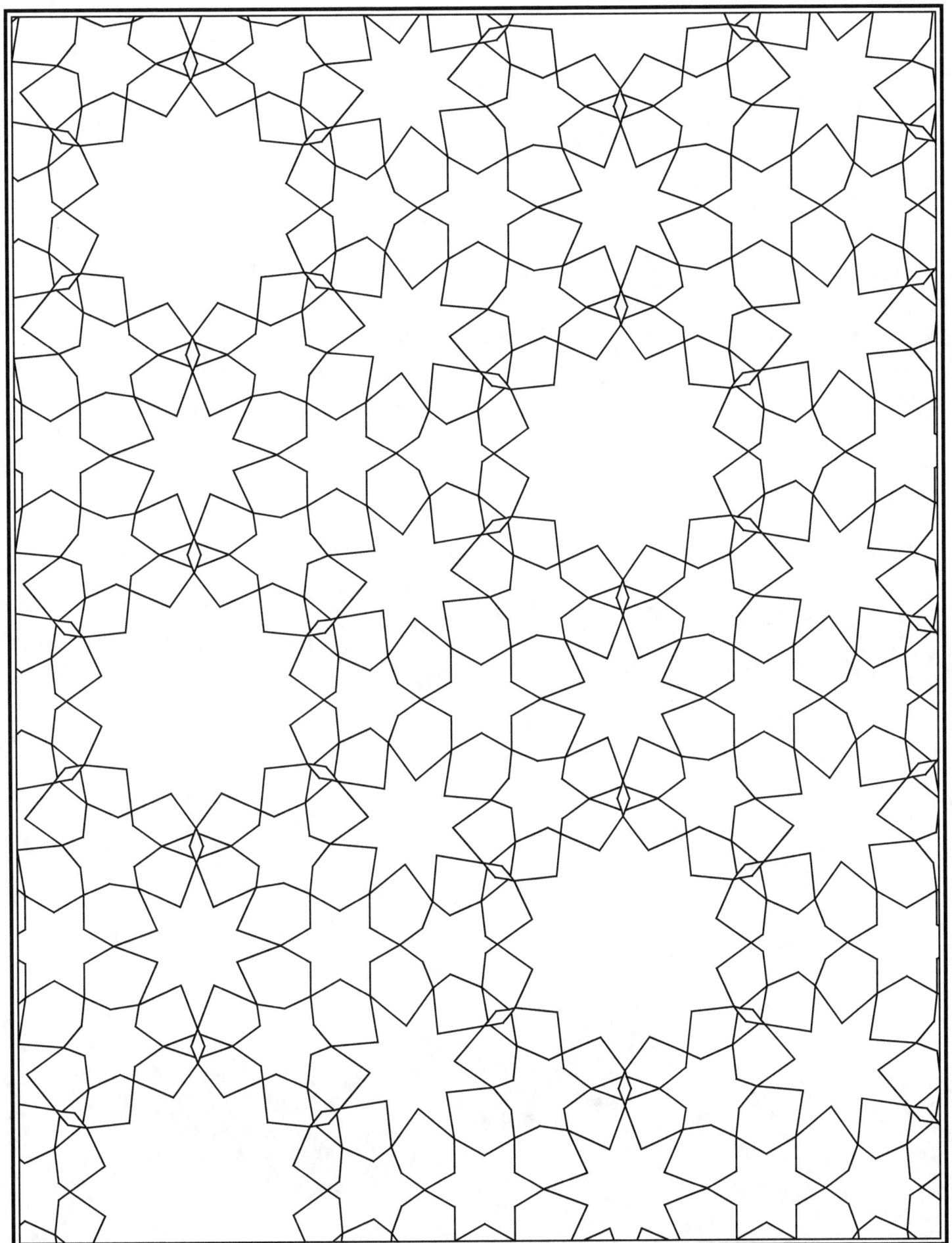

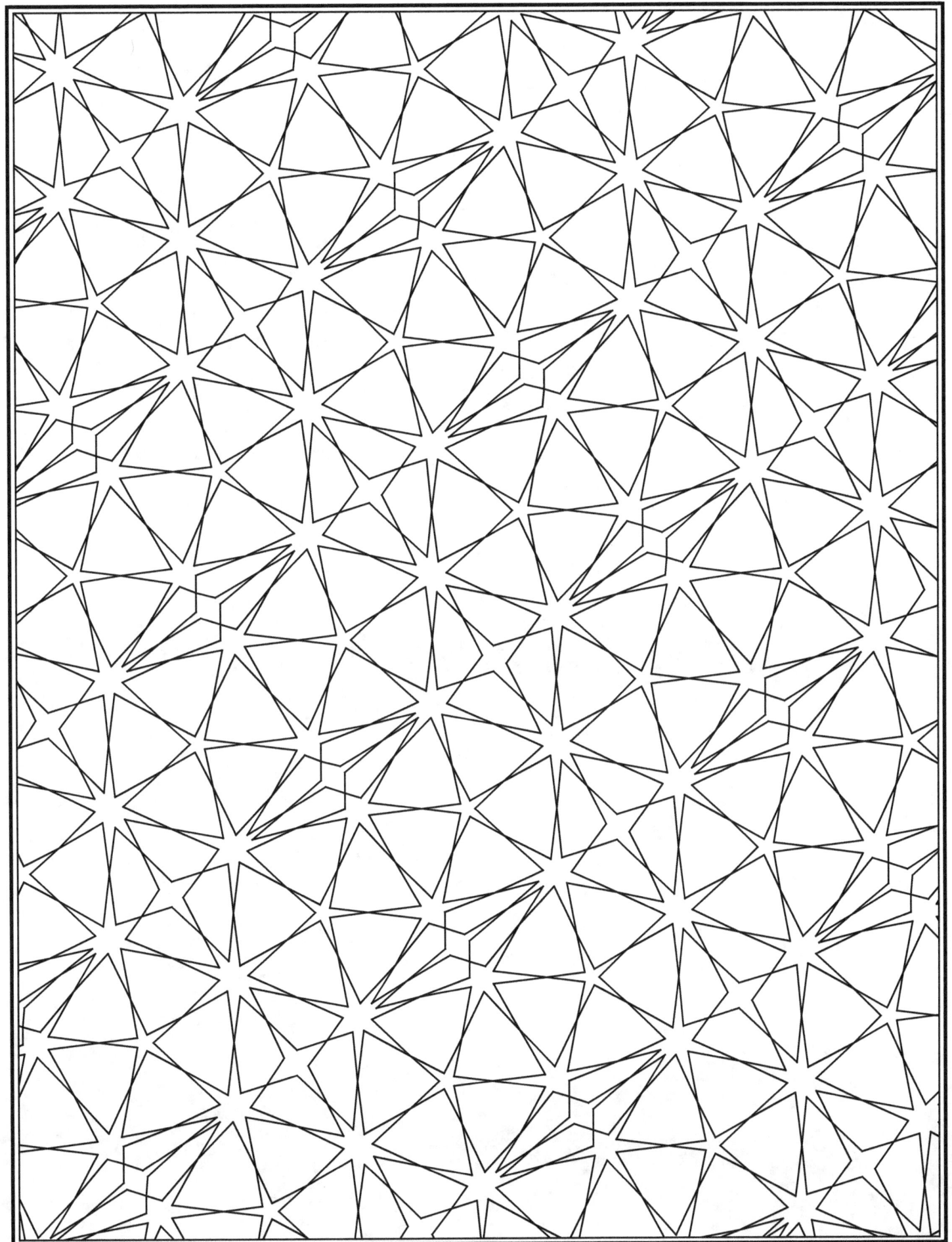

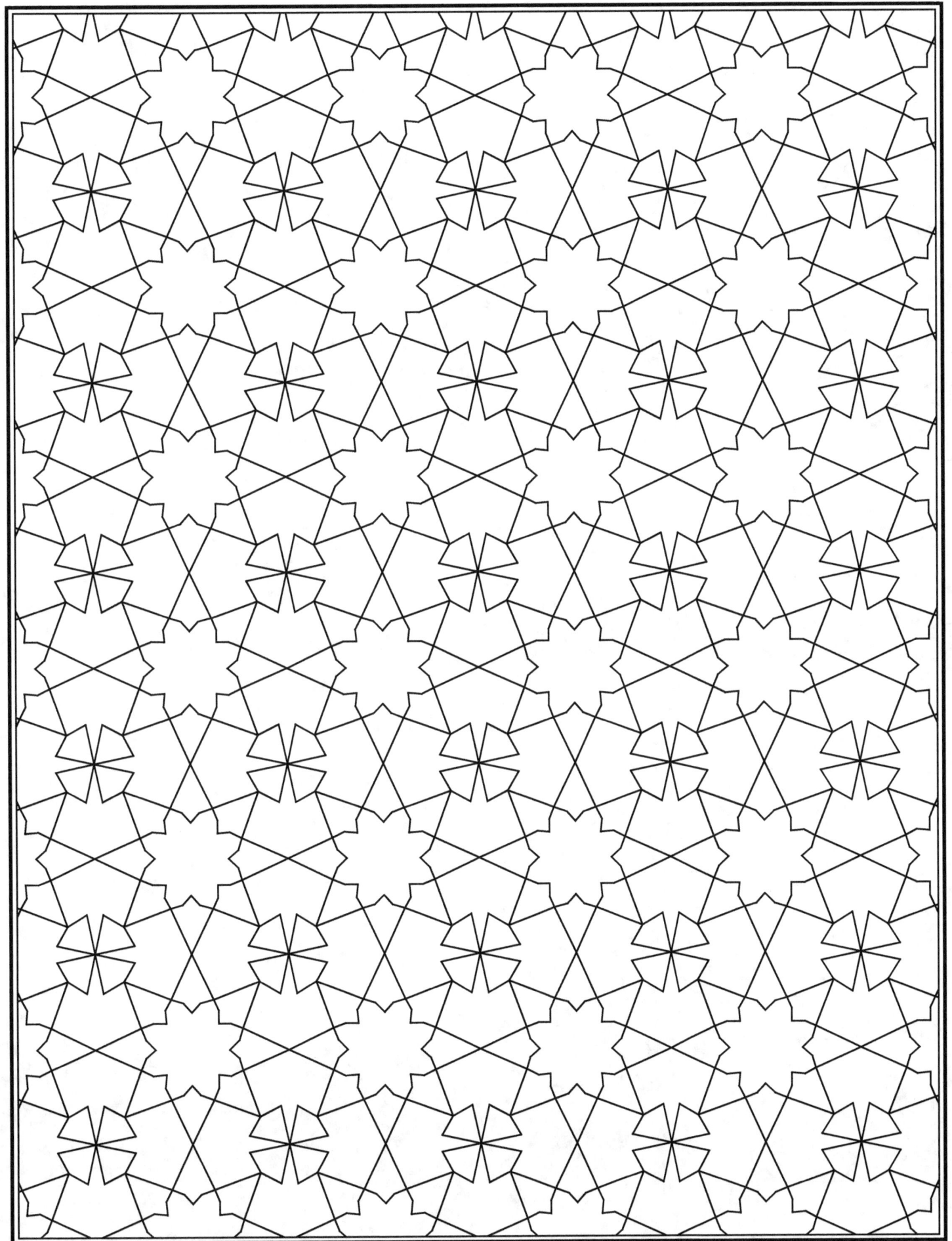

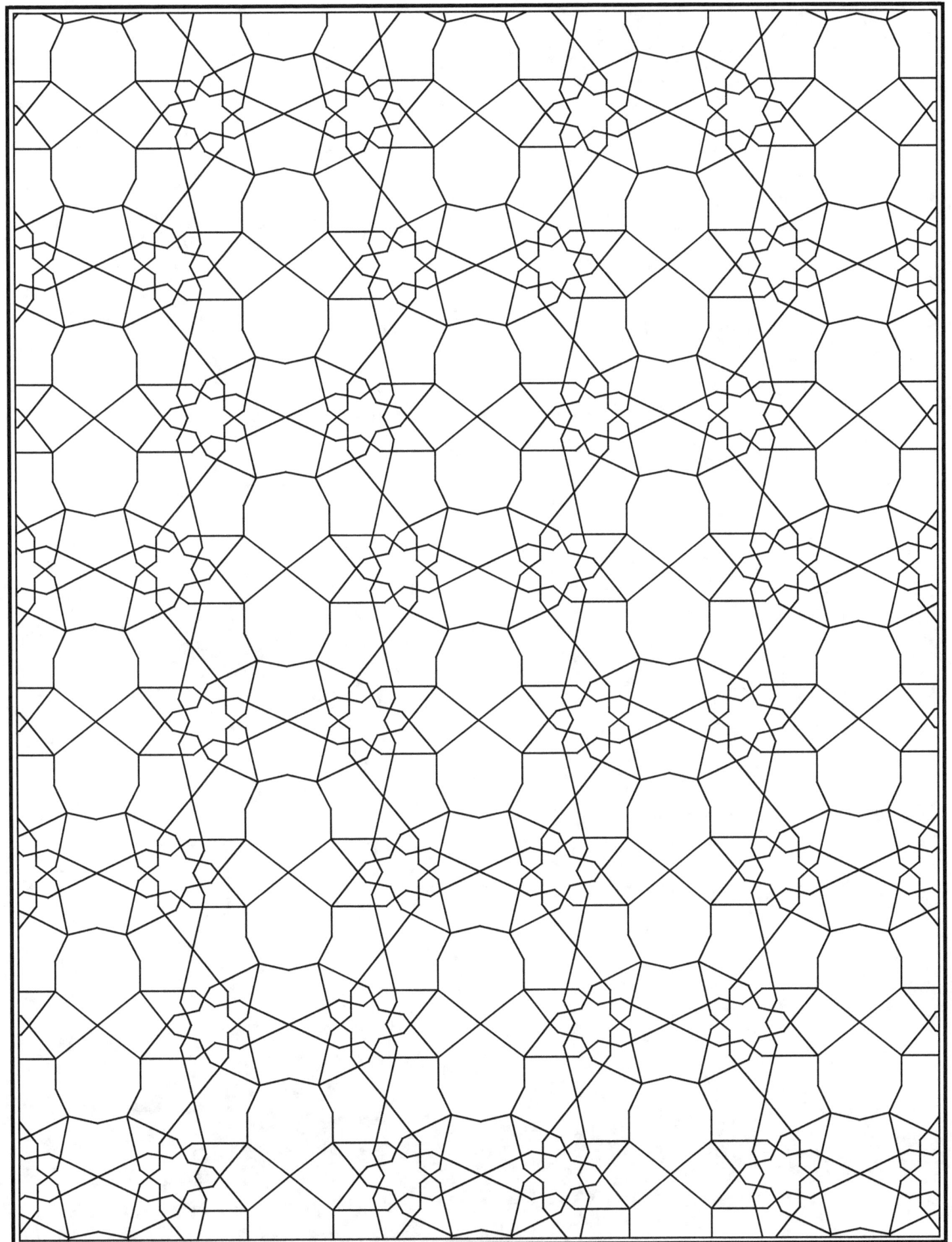

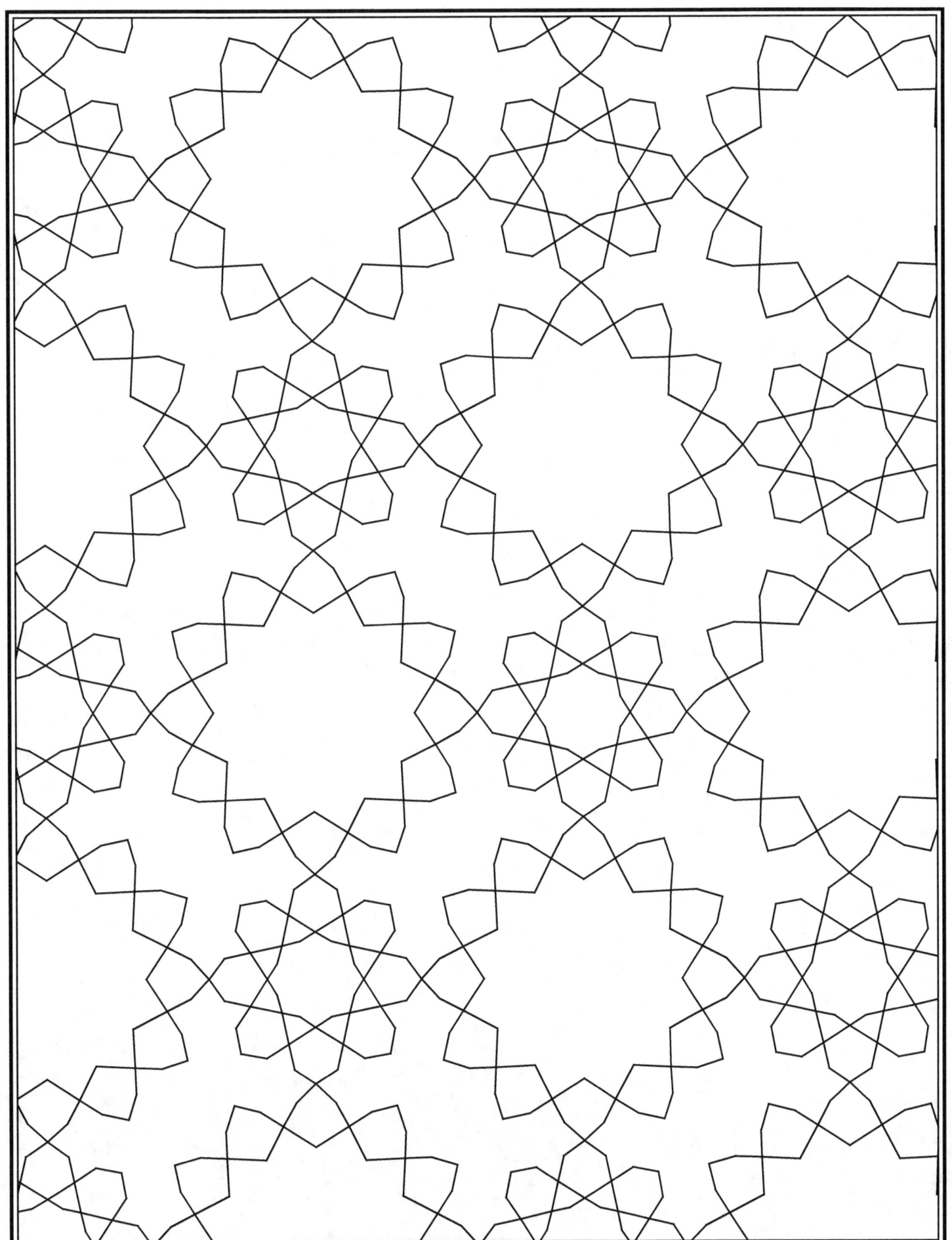

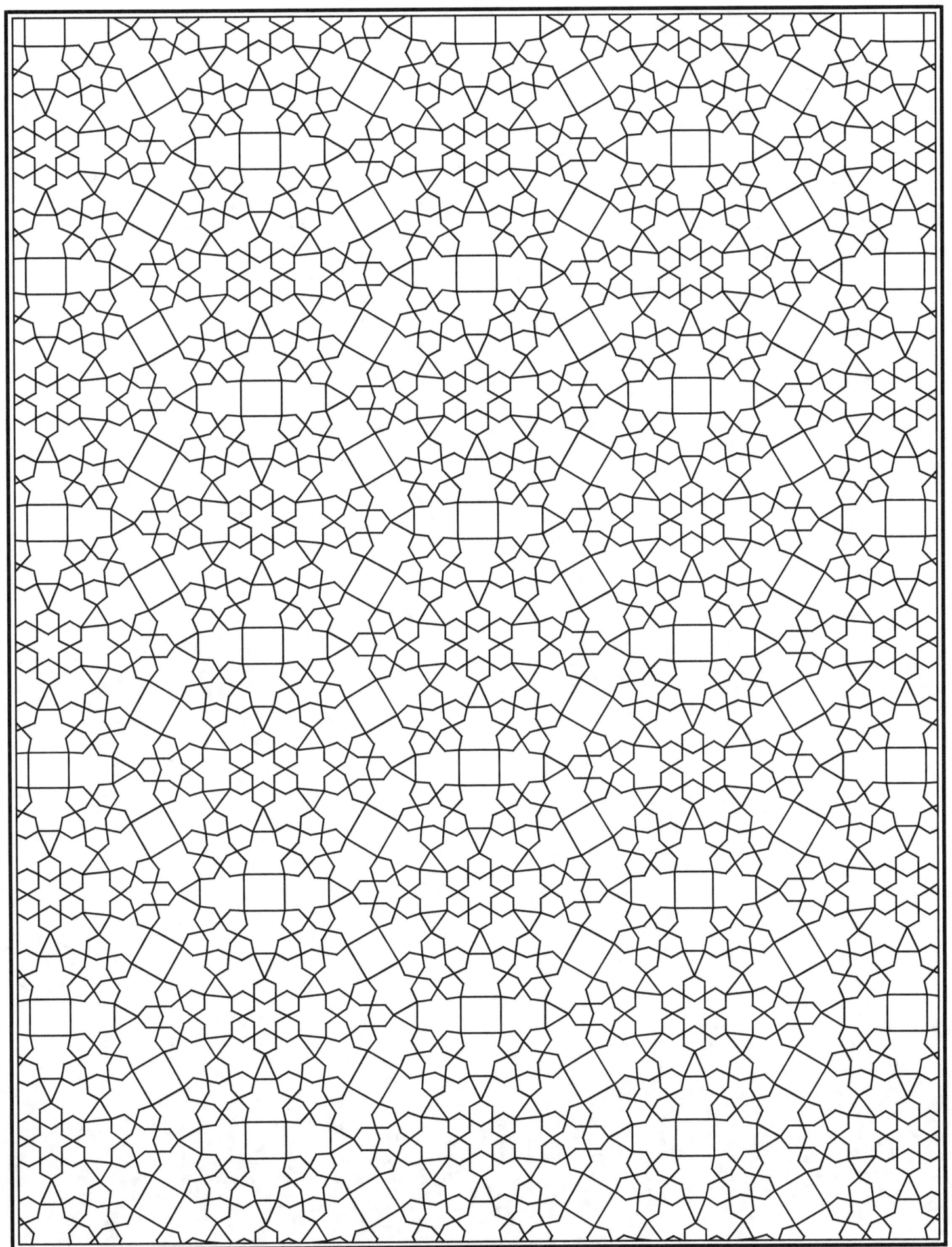

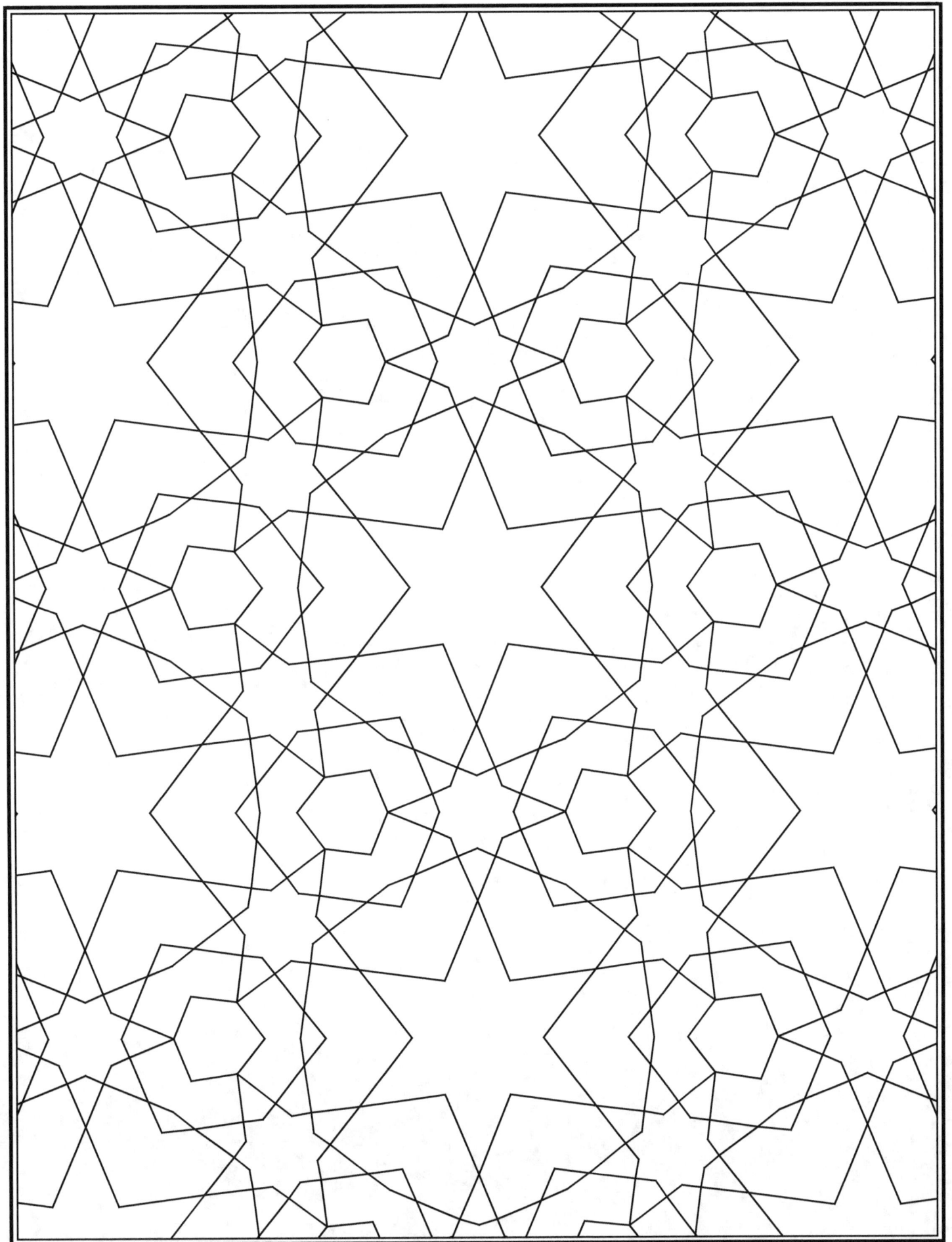

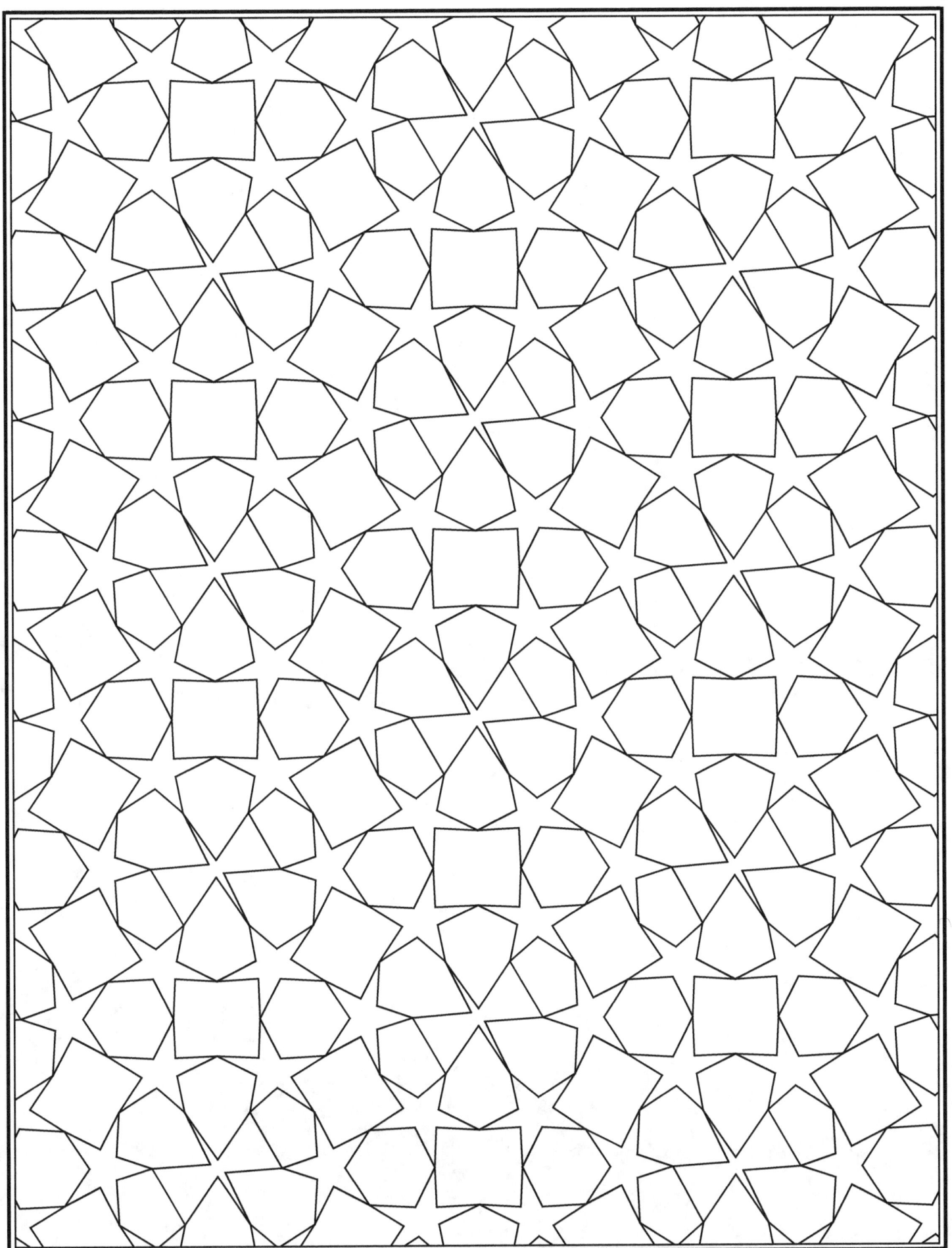

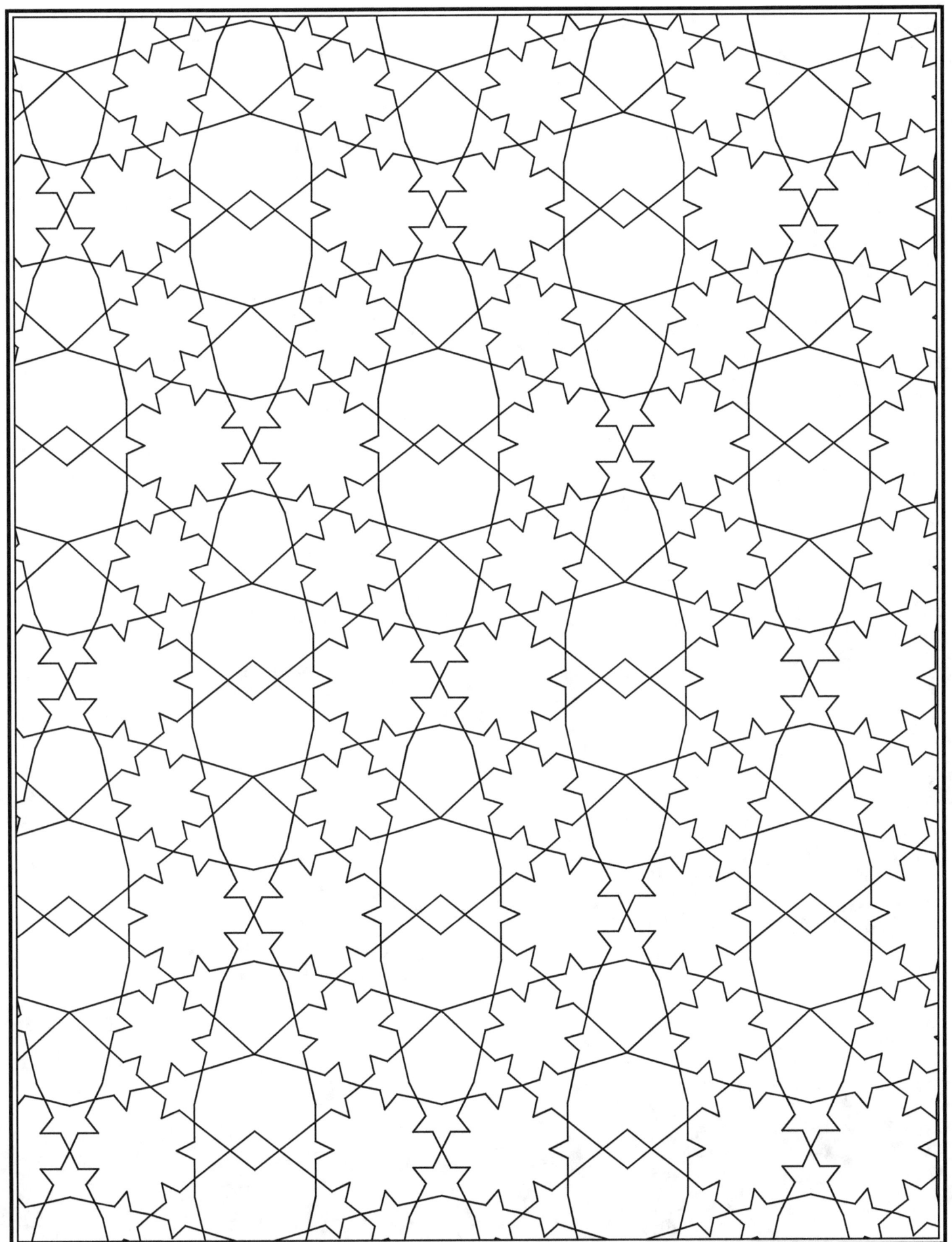

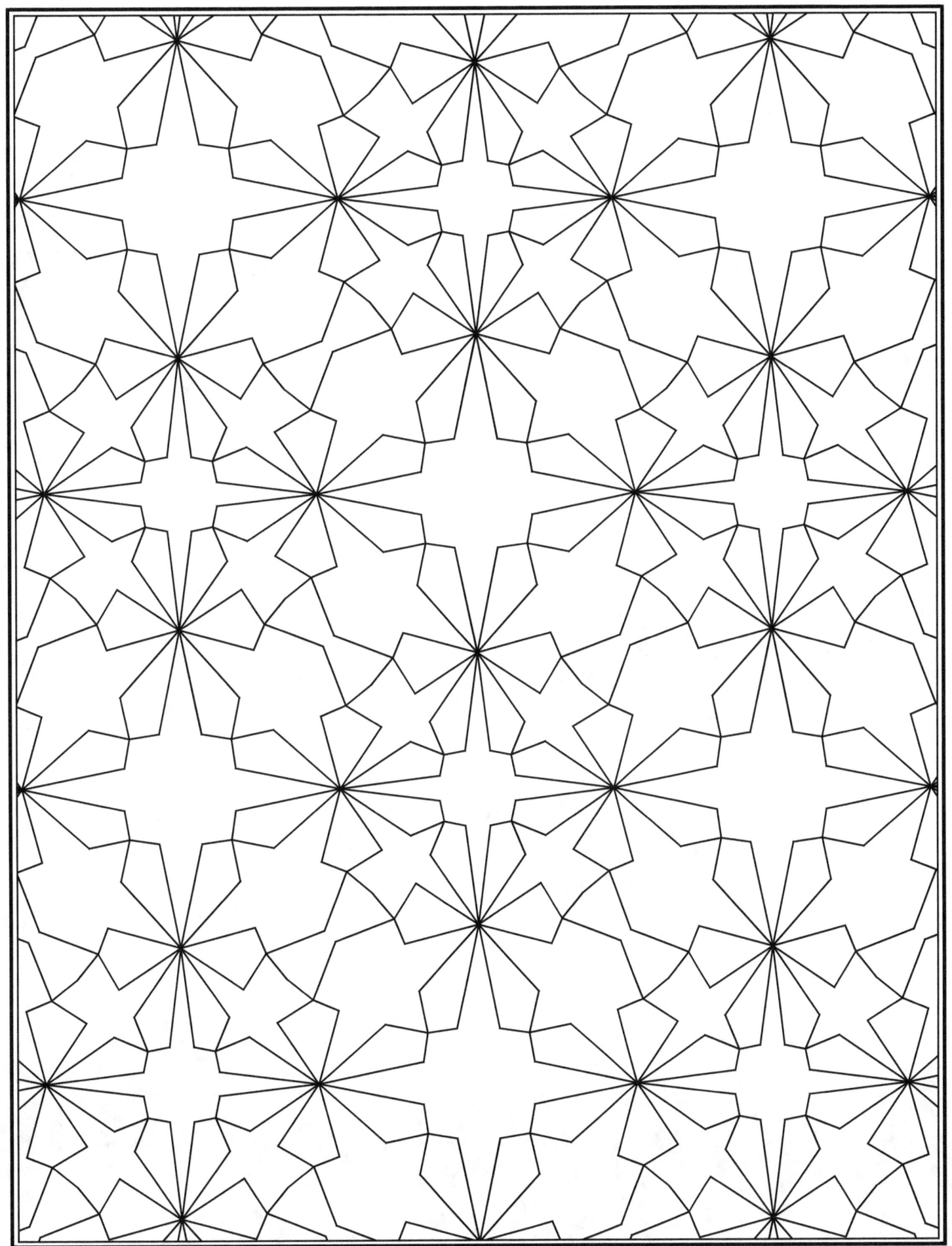

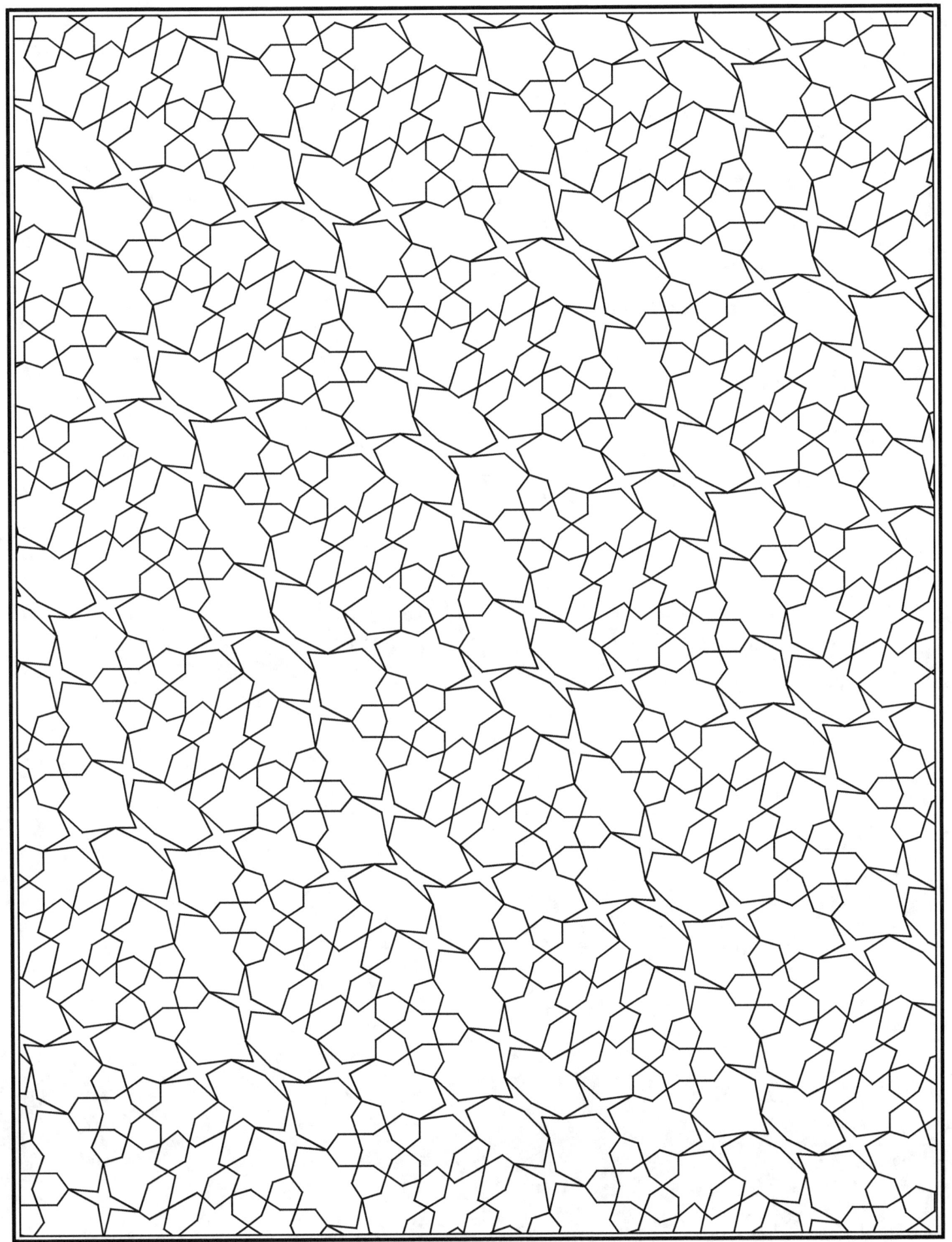

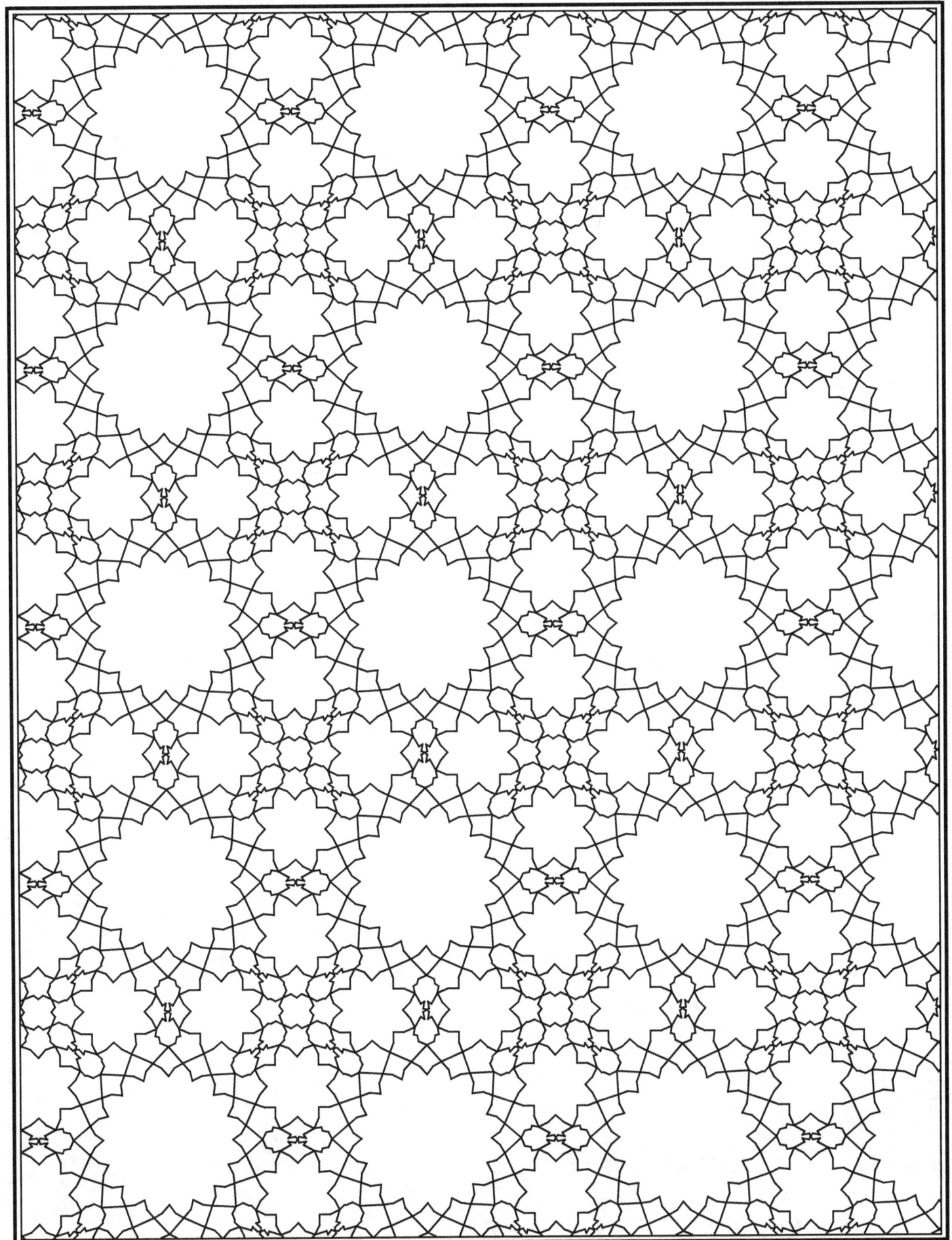

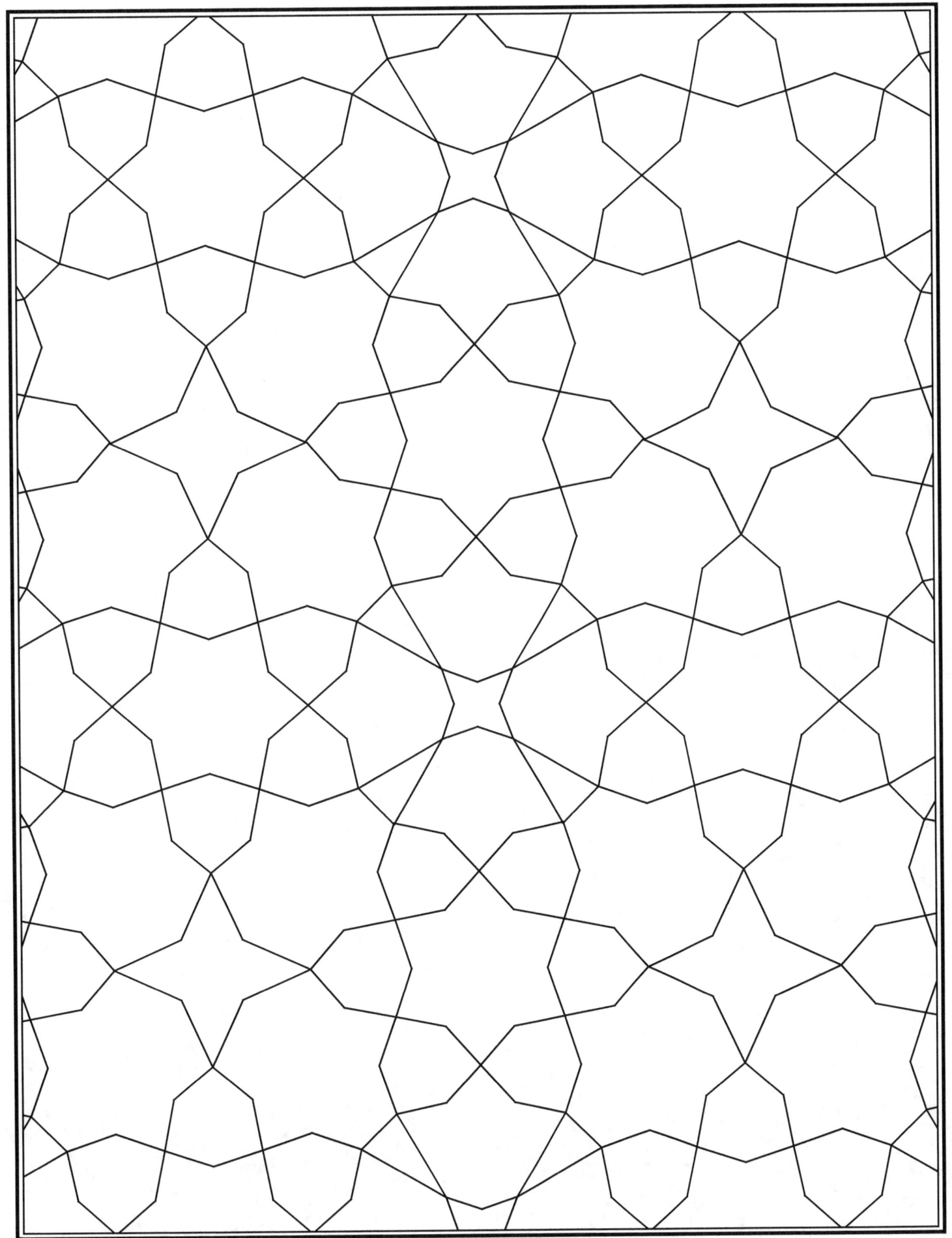

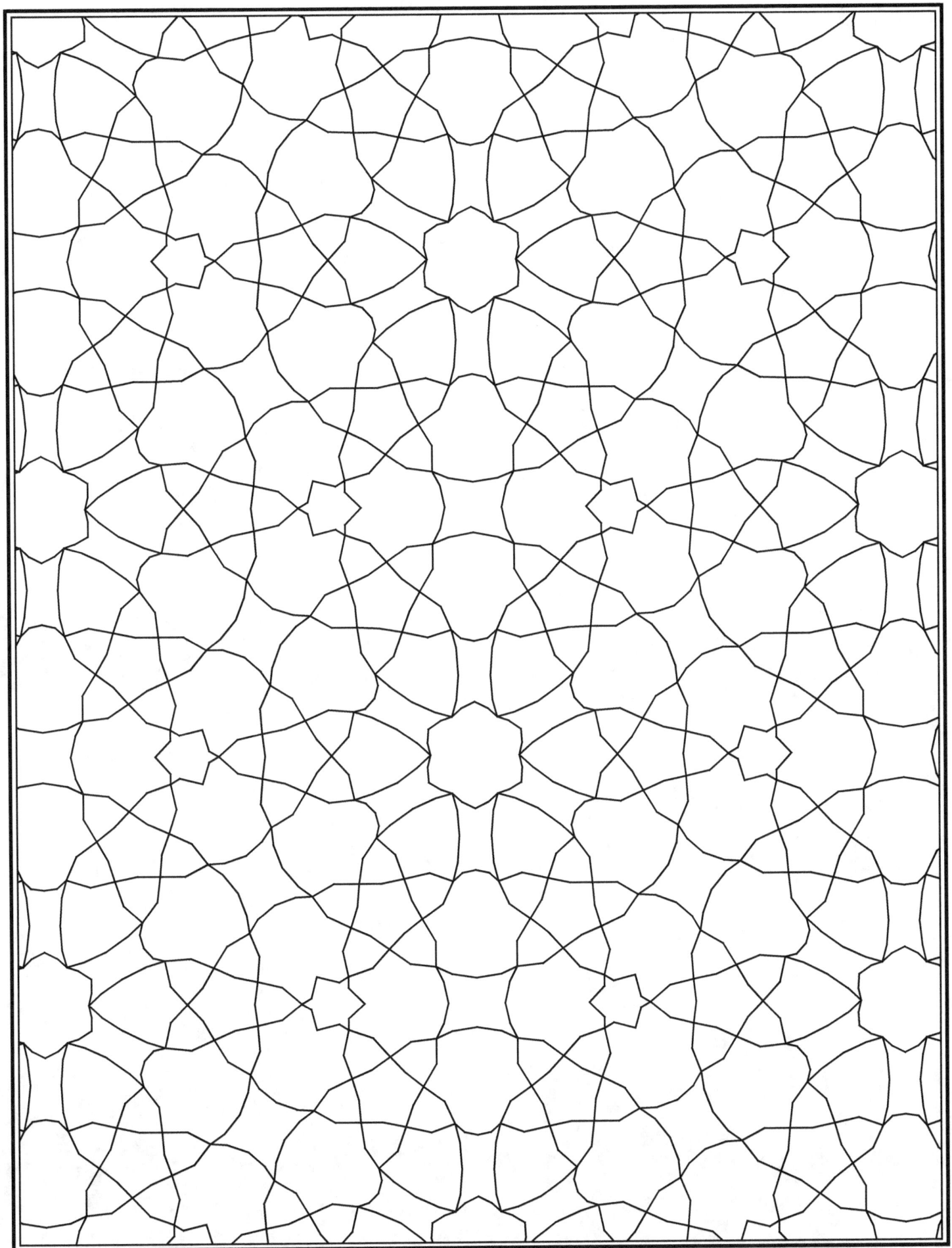

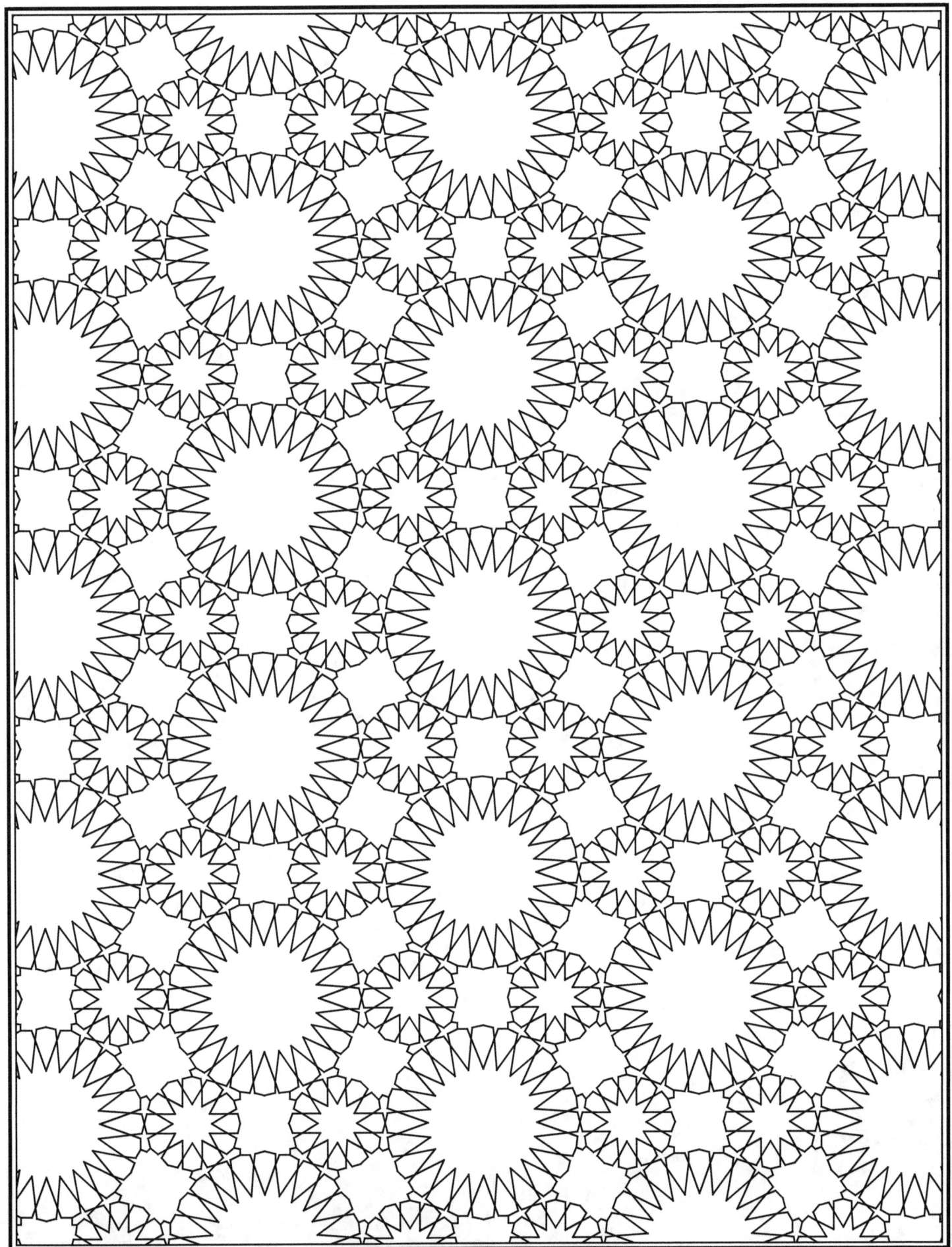

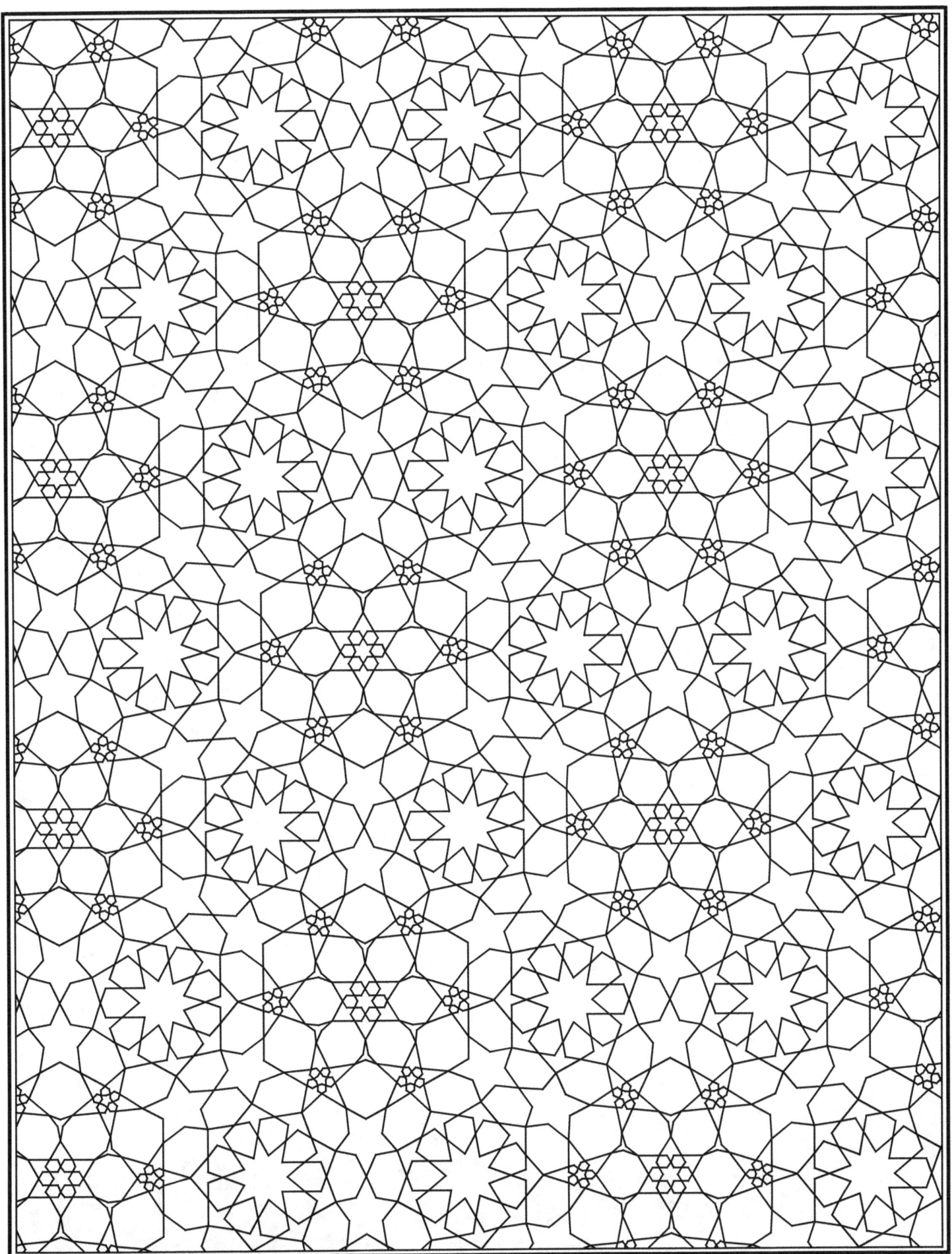

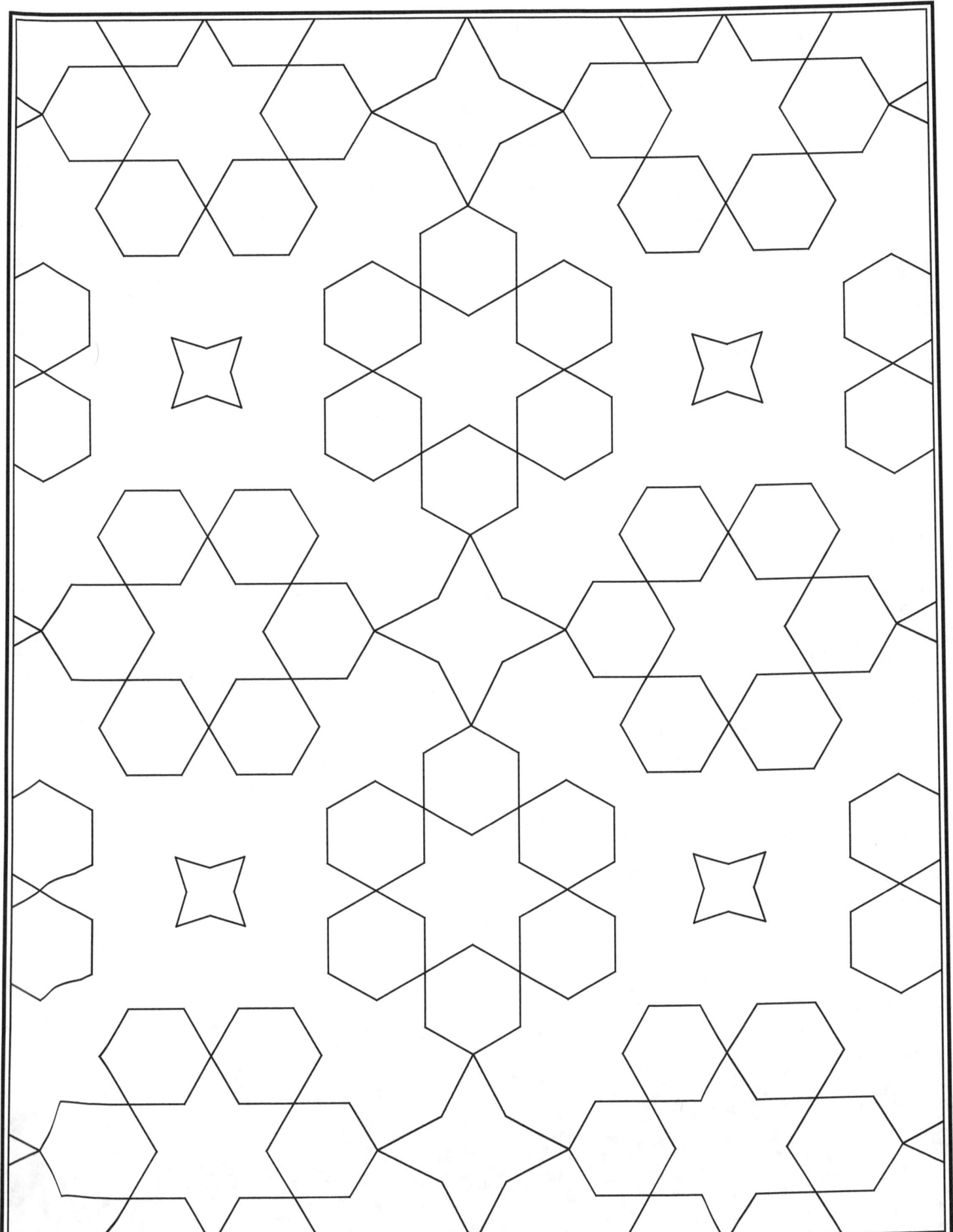

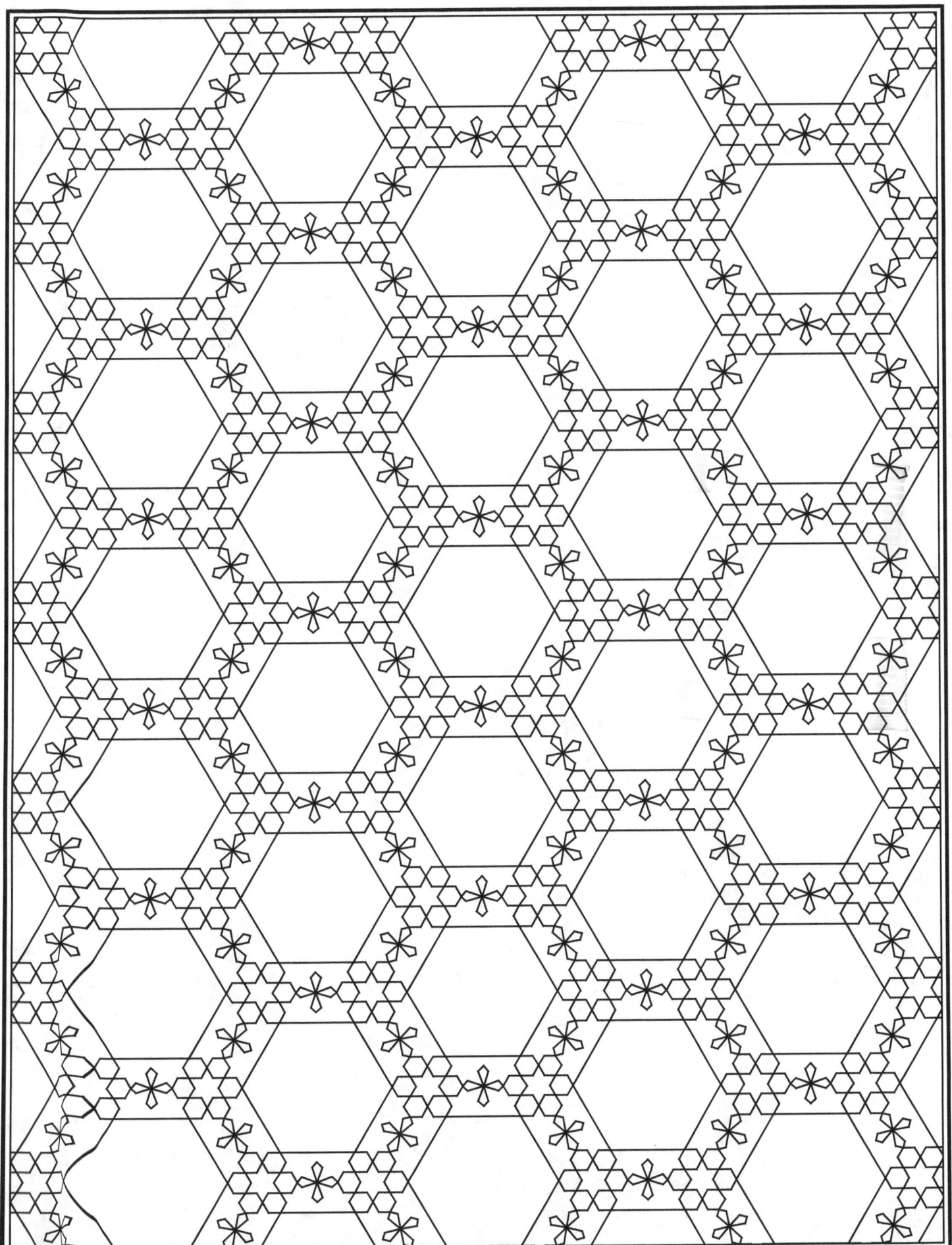

www.ingramcontent.com/pod-product-compliance
Lightning Source LLC
Chambersburg PA
CBHW080556220526
45466CB00010B/3167